IMAGES
of America

DETROIT GESU CATHOLIC CHURCH AND SCHOOL

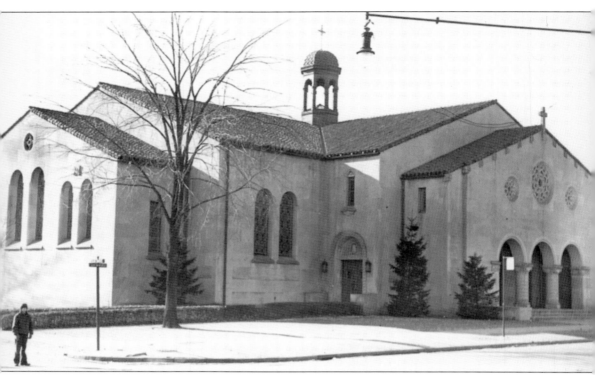

Gesu Catholic Church fronts Santa Maria Street, between Quincy Street and Oak Drive, in northwest Detroit. The parish was founded in 1922, and parishioners attended Mass in a converted farmhouse and the Gesu school basement before the Spanish Mission–style house of worship was opened in 1936. (Courtesy of Linda Rittersdorf Keimig.)

ON THE COVER: Here is a familiar school day sight to legions of Detroit Gesu School students. Sister Stella Rabaut, who was Gesu principal from 1971 to 2000, watches as students exit the school's east-side exit on Oak Drive. The school has been a landmark on McNichols Road, just east of Livernois Avenue, since 1925. (Courtesy of Gesu Parish Archives.)

IMAGES
of America

DETROIT GESU
CATHOLIC CHURCH
AND SCHOOL

Patricia Montemurri

Patricia Montemurri

10·15·2017

ARCADIA
PUBLISHING

Published by Arcadia Publishing
Charleston, South Carolina

Printed in the United States of America

Library of Congress Control Number: 2017941316

For all general information, please contact Arcadia Publishing:
Telephone 843-853-2070
Fax 843-853-0044
E-mail sales@arcadiapublishing.com
For customer service and orders:
Toll-Free 1-888-313-2665

Visit us on the Internet at www.arcadiapublishing.com

The best things in my life are rooted at Detroit Gesu. With love and appreciation for my husband, Paul G. Diehl, '69, and for our daughter who was baptized at Gesu, Natalie J.M. Diehl, the great-granddaughter of Gesu Catholic Church architect George F. Diehl.

CONTENTS

ACKNOWLEDGMENTS

This book would not be possible without the support provided by Anita Sevier, community outreach coordinator at Detroit Gesu Elementary School, and the Reverend Robert Scullin, SJ, Gesu pastor. Many thanks also go to parish finance council members Bill Felosek, Therese Bellaimey, Ken Henold, Walter Redmond, Sandy Battle, Carol Chupka, and Gesu principal Christa Laurin; and to Roselyn Hurley, Erice Rainer, Michael Heslip, Allison Cutuli, and Carl Threat for helping me at the parish whenever I asked.

Thank-yous are extended to Jennifer Meacham, Deborah Saul, Molly Hunt, and Sister Diann Cousino at the Sisters, Servants of the Immaculate Heart of Mary Motherhouse in Monroe; archivists Patricia Higo at the University of Detroit Mercy, Alyn Thomas with Manning Brothers, and Elizabeth Clemens at the Walter P. Reuther Library at Wayne State University; Joe Kohn and Ned McGrath, who helped me obtain photographs from the *Michigan Catholic* at the Archdiocese of Detroit; Kathleen Galligan, Mary Schroeder, and Kathy Kieliszewski at the *Detroit Free Press* for photographs researched and retrieved; and Richard Burr, Pam Shermeyer, and John Greilick at the *Detroit News*.

Thanks go as well to the many photographers who granted us reproduction rights, including Michael Sarnacki, Richard Hirneisen, Mae Stier, and the family of the late Nemo Warr; Elaine Cousino of Elaine Studios; Judy Kuzniar; Jerry S. Mendoza, and Tom Hagerty. Thank-yous also go to James Eddy, Helen Marie Berg, Patricia Harrington, Guy Stanley, and Mark Lezotte for their assistance; to my longtime colleague and photographer Diane Weiss for extraordinary finishing touches; to journalist Bill McGraw for leading me to a better introduction for the book; and to Dan Austin, Terri Bellaimey, and Natalie Diehl.

Thank-yous are offered as well to Tom Hite, Ashley Averill, and Brendan Harmon at Hite Photo in West Bloomfield; Susan Matous (also known as Stella Gesu) and Doris Vansen for their shout-outs on Facebook; to all the Gesu parishioners and alumni who contributed photographs, even if we could not use them all in the book; and lastly, to the staff of Arcadia Publishing and the infinite patience of my title manager, Caitrin Cunningham, and production editor Tim Sumerel.

INTRODUCTION

Much about Gesu and its history is uncommon. A rare parish in Detroit run by Jesuit priests, Gesu sits near the busy corner of Livernois Avenue and McNichols Road, across from the University of Detroit Mercy. In the city's heyday, Gesu was one of the wealthiest parishes in one of the nation's wealthiest cities, its boundaries encompassing the mansions of Palmer Woods and middle-class bungalows in neighborhoods west of Livernois Avenue.

Among its parishioners have been noted business leaders and industrialists, including the Fisher brothers, who founded Fisher Body and constructed the iconic Fisher Building. Jerome Cavanagh, mayor of Detroit for eight years in the 1960s, was a parishioner, and his children attended Gesu School. Even the church's architectural style—Spanish Mission—stood out for its distinctiveness. Its unusual name means "Jesus" in Italian.

What drew me to Gesu was what it meant to my husband, Paul G. Diehl, and his family. His grandfather, George F. Diehl, was the church's architect. My husband's father, Gerald G. Diehl, was the architect who renovated Gesu in 1987 and who went to morning Mass daily before heading to the office.

My husband's mother, Jo Irving Diehl, and her sister, parishioner Mary Ellen Irving Bellaimey, were descendants of the German and Swiss-born family who founded Detroit Stained Glass Works, which designed Gesu's luminous windows. Uncle Henry Bellaimey, Mary Ellen's husband, had a set of keys to open Gesu for 6:30 a.m. daily Mass for decades.

My husband and his seven siblings were all Gesu Giants, and all eight of them had legendary Sister Agnes Therese for their kindergarten teacher. His first cousins, the seven children of Alice Diehl Hagerty and Jack Hagerty, also graduated from Gesu. From all of them, I learned how Gesu influenced so many lives and inspired life-giving service.

But what also intrigued me is Gesu's role in Detroit, as a microcosm of Catholic tradition and evolution in Detroit and as a mirror of the city's struggles and history. In my career as a *Detroit Free Press* journalist, one of my specialties was covering Catholic Church issues. As I chronicled the controversies pulsing through the worldwide church, I also wrote about the celebrations, changes, and upheaval in the Archdiocese of Detroit. That is where Gesu Catholic Church and Gesu School distinguish themselves as rarities in the Detroit landscape.

Detroit Gesu was built during a time of explosive growth in the city. From 1910 to 1920, Detroit's population doubled to one million people. The pace continued during the Roaring Twenties as Detroit grew by another 600,000 to 1,567,000 by 1930.

It was the decade when Detroit landmarks such as the Fisher Building, Detroit Institute of Arts, the Penobscot Building, and the Ambassador Bridge to Canada were completed. And it was when Gesu Parish, and its distinctive school building with a red tile roof, was born on farmland on the east side of Livernois Avenue, in an area of northwest Detroit yet to be incorporated into the existing city limits.

Gesu Parish grew out of expansion plans for the University of Detroit, the Catholic institution founded by the Jesuit order of priests on East Jefferson Avenue near the Detroit River in 1877. The Reverend John P. McNichols, the university president, purchased farmland several miles north of downtown in 1921 to relocate the campus. After his death in 1931, the city renamed Six Mile Road in his honor.

Along with the land purchase came the old farmhouse, and McNichols converted the wood-frame home, heated by a potbellied stove, to serve as a temporary church. His name for the farmhouse mission, Gesu, is the name of the first Jesuit-run church in Rome.

The first Mass was celebrated on March 19, 1922, before some 25 people. Through spring festivals and card parties in their homes, parishioners raised money to buy nearby land and erect the Gesu School building in 1925. Architect B.C. Wetzel, a native of Frankenmuth, Michigan, was selected as the school's architect.

On September 8, 1925, Gesu School opened its doors. After first attending Mass in the farmhouse mission, celebrated by the pastor, the Reverend Justin De La Grange, the children crossed over a field and wooden planks to enter the school doors because there were no sidewalks. And at the new school, there were no seats at their desks. After registering, they were dismissed for a week to allow for the finishing touches.

Since that opening day of Gesu School, a member of the Sisters, Servants of the Immaculate Heart of Mary (IHM) congregation has always worked at the parish.

The first nuns to serve Gesu—Mother Lucilla and Sisters Mary Claude, Eleanor, Muriel, and Rose Ethel—considered their new assignment to be a "pioneer existence," according to a chronicle of their arrival. "Among other things we found that there was no grocery store in sight."

IHM Sisters, whose congregation was founded in Monroe in 1845, welcomed 200 students to the 16-classroom school. Church services moved from the farmhouse to the school's basement.

Gesu parishioners, at the time of its founding, were middle-class and upper-class Catholics, mostly of Irish and German descent.

Just five years after it opened, Gesu School enrollment had increased to 948 students, and new additions to the school were erected in 1927, 1928, and 1930.

Even as the nation struggled through the Great Depression, Gesu School and church grew. In 1935, construction began for a church, located just north of the school. The Spanish Mission–style church cost upwards of $225,000. By 1939, the convent was built, and 20 Sisters moved in from three houses they had rented on Quincy Street.

The *Detroit Free Press* described Gesu as "one of the fastest growing parishes in this part of the country" in an article about the church's dedication in 1937.

Throughout its existence, Gesu has mirrored the community and adapted to the city's evolution, grappling with all the socioeconomic and racial challenges that have strained America's Rust Belt cities—and most acutely Detroit.

Detroit's peak population of 1.8 million residents came in 1950, after decades of massive immigration from European countries and a surge of African Americans from the American south.

Nearly 75 percent of Detroit's white population was Catholic in the 1950s, according to Thomas P. Sugrue, author of *Origins of the Urban Crisis: Race and Inequality in Postwar Detroit*. In 1964 and 1965, the Archdiocese of Detroit school directory listed 108 Catholic elementary schools in Detroit, Hamtramck, and Highland Park. There were some 120 Catholic churches across the city.

When Gesu was at its peak enrollment in the mid-1960s, it was one of the largest Catholic elementary schools in the Archdiocese of Detroit. Some Gesu students attended classes at a satellite location at St. John Vianney Parish in Highland Park because Gesu was not large enough to handle demand.

While the neighborhood around Gesu was split evenly between Catholic, Jewish, and Protestant families, it was almost exclusively white until the early 1960s. As middle-class black families moved into the neighborhood, Gesu itself became much more diverse.

Detroit's population decline began in the 1950s, as families sought cheaper housing in the suburbs and followed jobs to new auto plants outside the city. The 1967 Detroit riot accelerated the exodus.

"As more and more African Americans moved into northern cities like Detroit, the local Catholic Church was forced to confront its own prejudices and racism," wrote Gesu's pastor, Fr. Robert Scullin, SJ, when Gesu celebrated its 90th anniversary in 2012. "The 1967 riots left lasting scars. If at first Gesu, like other Catholic parishes, resisted diversity, parish leaders at that

time promoted the diversity that church members cherish today," Gesu's leadership during this time of great change sought to stress Catholic teaching to bridge the city's racial divide. Faith congregations struggled with the riots' aftermath, and Gesu parishioners dealt with racial tensions and prejudice.

When some white students were rude to African American newcomers, Gesu's pastor, the Reverend John Schwarz, led them to a black family's house to apologize. And when Schwarz saw white parishioners ease out of a pew after black parishioners sought seats at Mass, Schwarz told the white Catholics to keep moving out the door, Father Scullin recalls.

Gesu parishioners drew up a policy statement to embrace integration and started small group discussions between blacks and whites in parishioner homes. Pastor Schwarz ensured the integration of the parish's ushers club when members of the all-white men's group initially resisted. These details about how Gesu handled race relations are explored by Helen Marie Berg, a Gesu School alumna, through "In Unity There is Hope: The Story of a Detroit Parish," her 2012 senior thesis at the Catholic University of America.

The Reverend James Serrick continued the outreach in the early 1980s. He brought a national program, Christ Renews His Parish, to Gesu. Through weekend retreats designed to generate spiritual renewal, black and white parishioners grew to know each other better. Longtime parishioners say that was a turning point in unifying the congregation. Serrick wanted to foster inclusive worship and hired a new music director accomplished in both classical and African American music. The change upset many, including choir members at the time, but under Carl Clendenning, still Gesu's music director, a diverse congregation has explored and embraced a variety of musical expression.

Detroit's decline has continued through recent decades, amplified by the Great Recession of 2008, the housing foreclosure crisis, and Detroit's declaration of bankruptcy in 2013.

Detroit's population in 2016—an estimated 673,000—is less than what it was when Gesu was founded in 1922. In 2017, only four Catholic elementary schools remain open in Detroit.

Even when Gesu was no longer a community of young families, the parish committed to maintaining a school as part of its evangelization. Gesu is the largest of the four remaining Catholic grade schools in the city, and its student population of 240 students nearly matches its enrollment from when it opened its doors nearly a century ago.

Gesu Parish has not only survived—there are under 50 Catholic parishes in Detroit—but it has thrived. Gesu remains anchored in the Catholic faith and social outreach.

The Jesuit order of priests and brothers continues to lead the parish, but there are no longer IHM Sisters teaching in the grade school; the school is now staffed entirely by lay teachers. Yet an IHM nun, Sister Angela Hibbard, continues the IHM record of service at Gesu. She is the parish's pastoral associate, and one of her duties is to help prepare converts to the Catholic faith and new members of Gesu Parish to receive the Catholic sacrament of Baptism. That she did in spring 2017 as the latest redesign and adaptation of Gesu Catholic Church took place. Under the architectural expertise of Mary Clare McCormick, Gesu '76, a new baptismal font and pool—suitable for immersion—was added beneath the western windows.

In a city plagued by stubborn high unemployment rates and crime, Gesu remains a landmark in one of Detroit's most desirable neighborhoods. But Gesu has been a sanctuary of stability and service, adapting to serve the evolving community it anchors and nurtures.

One

THE BUILDING BLOCKS

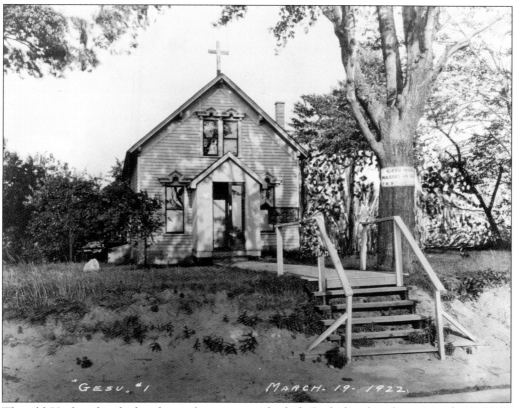

The old Horkey family farmhouse became a makeshift Catholic church on March 19, 1922, when the Reverend John McNichols celebrated Mass in the newly christened Gesu mission on the outskirts of northwest Detroit. McNichols, a Jesuit priest and president of the University of Detroit, paid $120,000 in 1921 to purchase farmland to relocate the college from its location near the Detroit River. (Photograph by M.J. McCurdy, courtesy of Gesu Parish Archives.)

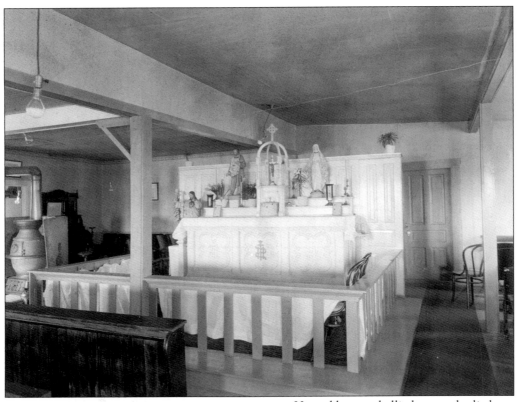

Heated by a potbellied stove, the little church was located south of the current Gesu. Among recorded attendees at the first Gesu Mass were John Yelnick and family, Mr. and Mrs. Patrick Kearns, Mr. and Mrs. Pierce Butler, Mrs. Middleton and her daughter Margaret, Mrs. Joseph Walter and family, Mr. and Mrs. Lohman, and two other priests. (Courtesy of Gesu Parish Archives.)

Fr. John McNichols was president of the University of Detroit from 1921 to 1928 and moved Michigan's first, oldest, and biggest Catholic university from downtown to northwest Detroit. It is now known as University of Detroit Mercy. McNichols also established its graduate school and School of Dentistry. After he died, the city renamed Palmer Road, also known as Six Mile Road, after McNichols. (Courtesy of University of Detroit Mercy Archive and Special Collections.)

FIFTY YEARS AGO

~University of Detroit 1878~

By this time the University District had been cleared of its timber and settled by a colony of German and Bohemian farmers and truck gardeners. The Kubick farmhouse stood on the sand ridge near Six Mile and Livernois. The Horkey homestead stood just north of the Physics Building.

Gesu and the University of Detroit sprouted from swampland and longtime farmland, and this map from the late 1880s shows property owners in this rural patch outside Detroit. Much of the area was a swamp where tamaracks, cranberry bushes, and willows grew, according to a University of Detroit Mercy history. With the dawn of the auto industry, some early residents cleared the land for truck facilities. On this map, the Horkey farm, where Gesu Catholic Church began, is marked Harvey. In the upper right corner, note the property parcel belonging to T.W. Palmer. Thomas Witherell Palmer was a US senator from Michigan and large landowner, in part from an inheritance from his grandfather, also a politician and judge. Part of Palmer's landholdings became the upscale neighborhood known as Palmer Woods, and Palmer donated 140 acres for a city park known as Palmer Park. (Courtesy of University of Detroit Mercy Archive and Special Collections.)

13

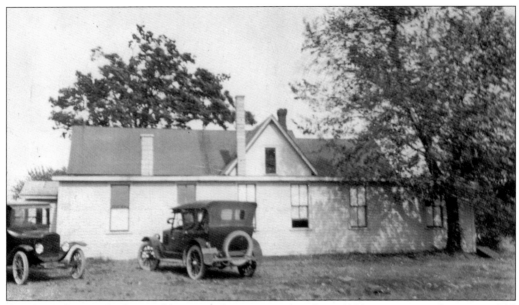

Gesu parishioners built an addition to the mission church in 1923 to accommodate up to 300 people and started fundraising for a school. The farmhouse church was located close to Livernois Avenue and Grove Street, south of where Gesu Parish is now. Father McNichols, consumed by building a new university campus, turned over Gesu pastor duties to the Reverend Justin De La Grange. (Courtesy of University of Detroit Mercy Archive and Special Collections.)

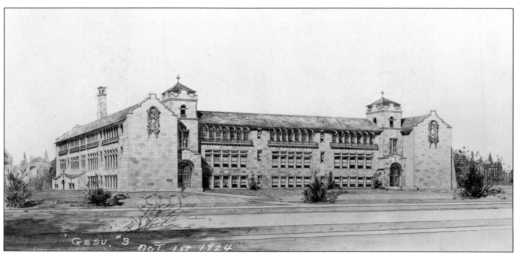

Architect Bernard C. Wetzel, a native of Frankenmuth, Michigan, was chosen to design an elementary school for Gesu. Wetzel had come in second place in a contest to design a campus for the relocated University of Detroit. A copy of this Gesu rendering appears in the August 17, 1924, *Detroit Free Press*. (Courtesy of Gesu Parish Archives.)

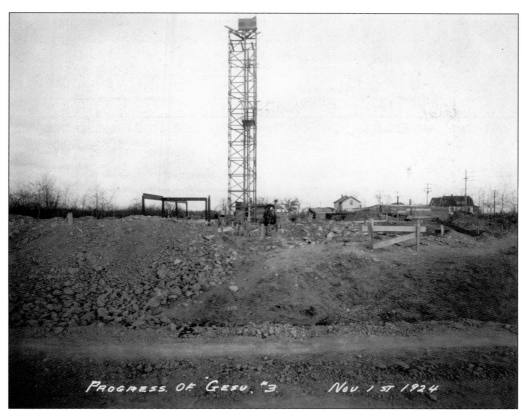

PROGRESS. OF GESU. #3. Nov. 1 st 1924

By November 1924, shovels were in the ground to build a school for Gesu. Wetzel's grand design showcased a 40-room school, at an initial cost of $400,000, according to the *Detroit Free Press* story. Even as winter approached, construction continued. Parishioners raised construction funds through card parties in their homes. The plans for the school called for Indiana limestone on the exterior and interior walls to be done in light buff brick. (Both, courtesy of University of Detroit Mercy Archive and Special Collections.)

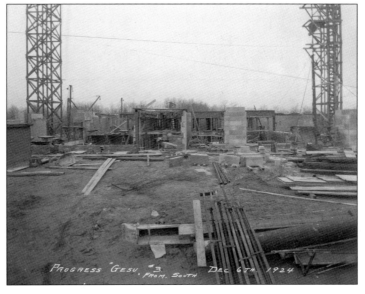

PROGRESS GESU. #3. FROM SOUTH DEC 6TH 1924

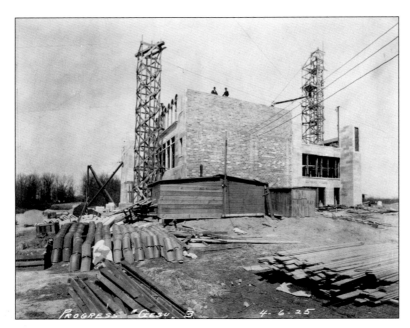

By April 6, 1924, the school's walls were up and bricked. And two gents of the day made it to the roof to survey the still-rural landscape. (Courtesy of University of Detroit Mercy Archive and Special Collections.)

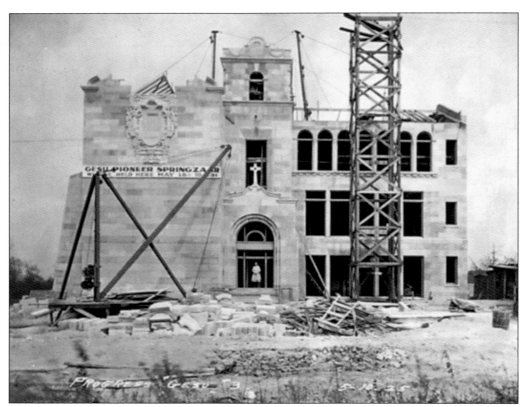

Gesu School takes shape in this photograph from May 1924, and perhaps it was the dream of the girl standing in the doorway to attend here. Stretched across the school is the banner for the "Gesu Pioneer Springzaar." It was a fundraiser that featured baked goods and crafts made by parishioners. (Courtesy of University of Detroit Mercy Archive and Special Collections.)

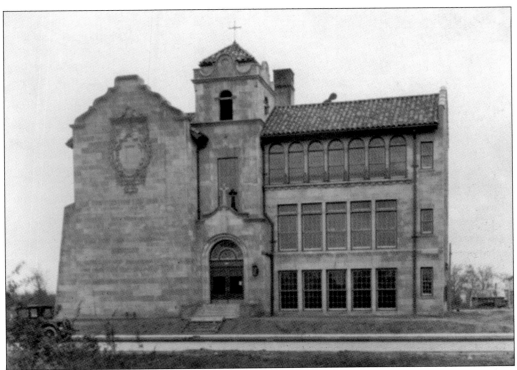

Gesu School opened on September 8, 1925. Some 200 children registered for classes, and their teachers were five members of the Sisters, Servants of the Immaculate Heart of Mary (IHM) congregation in Monroe. But the students were sent home for a week because the furniture was not finished. (Courtesy of University of Detroit Mercy Archive and Special Collections.)

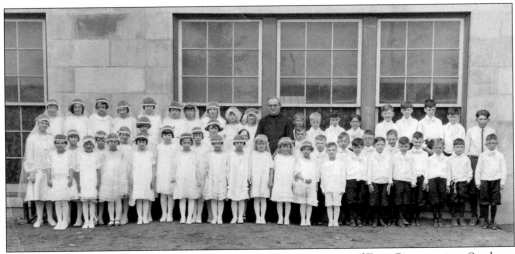

On May 16, 1926, some 50 Gesu children received the sacrament of First Communion. Students posed with Gesu pastor Justin De LaGrange. Several months earlier in October, the last Mass was celebrated in the farmhouse church, and parishioners moved the altar into the school's basement chapel for services. No more would students take the trek between the farmhouse church and school. "We have taken our last morning walk through the fields of clover," noted the IHM nuns' convent chronicle. (Photograph by W.J. McCurdy, courtesy of Gesu Parish Archives.)

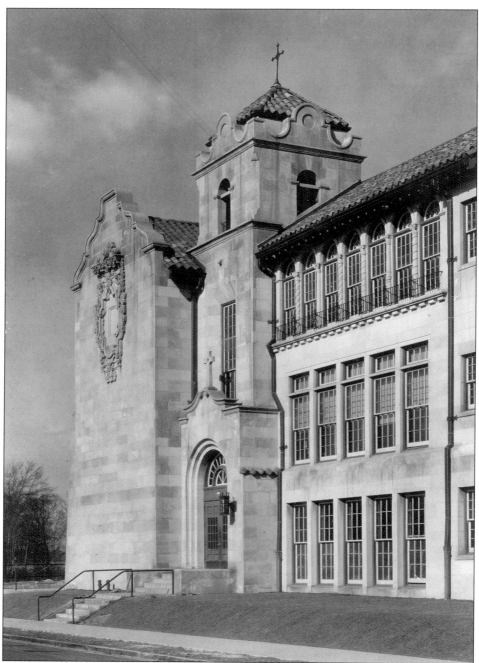

Gesu School, with its red tile roof and distinctive stonework, was a neighborhood landmark and beacon. Inside the school, the students were taught by IHM Sisters, who kept regular notes of special school events. The IHM chronicles note that on December 21, 1925, the last day before the Christmas break, "through the kindness of Mr. Fredericks, the children enjoyed a movie in the upper corridor." Santa Claus visited classrooms that day and presented each Gesu student with a box of candy. Another special day that first school year was when Detroit auxiliary bishop Joseph Plagens visited Gesu to confer the sacrament of Confirmation. (Courtesy of University of Detroit Mercy Archive and Special Collections.)

The Gesu eighth-grade graduates of 1927 assembled at the schoolhouse door for a portrait. Seated amidst them is Gesu's pastor Fr. Patrick Harvey. In the top row is assistant pastor Fr. E.A. Barton. (Photograph by W.J. McCurdy, courtesy of Gesu Parish Archives.)

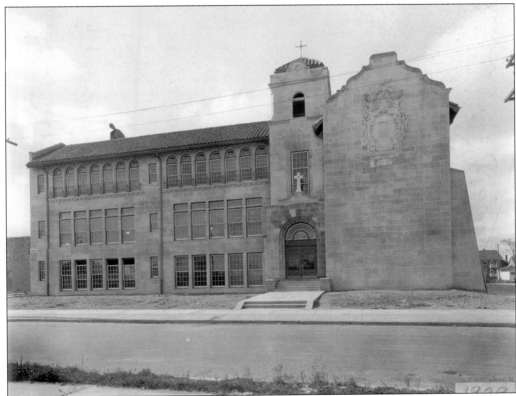

More classrooms were added to the school between 1926 and 1930 to accommodate additional students. It was a period of intense development throughout Detroit. Many upscale brick homes, built in the Tudor Revival style and able to accommodate large families, had gone up just north of Gesu, in the University District and College Park neighborhoods. (Courtesy of University of Detroit Mercy Archive and Special Collections.)

The graduates of Gesu's eighth-grade class in 1929 pose with Gesu pastor the Reverend D.E. Hamilton. (Courtesy of Gesu Parish Archives.)

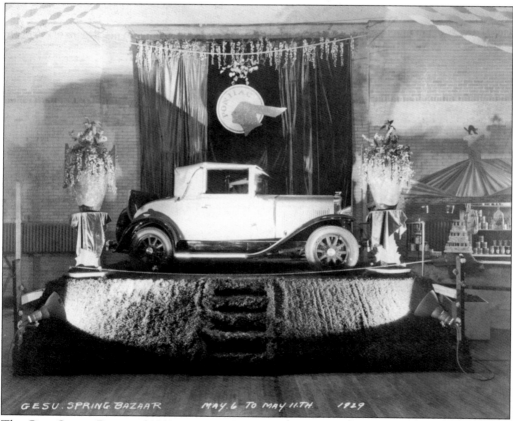

GESU. SPRING BAZAAR MAY. 6. TO MAY. 11.TH 1929

The Gesu Spring Bazaar of 1929 was considered the largest and most successful affair staged by the young parish. Among the grand prizes was this 1929 Pontiac, on display in the school hall. "The very sizable profits were used to swell the building fund," notes a parish history. According to the 1929 Gesu Spring Bazaar program, "a prize of $10 in gold" was awarded each evening "to the holder of the lucky number program." (Courtesy of Gesu Parish Archives.)

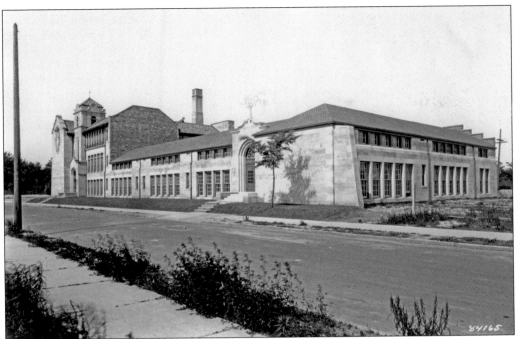

From another view, this photograph shows the additions made to Gesu School in its early years to handle the surge of students. By 1930, there were 15 IHM nuns and six lay teachers at Gesu School overseeing 950 students. During the same period, the IHM Sisters had built nearby Marygrove College for women and teaching majors came to Gesu for observation studies. (Courtesy of Indiana Limestone Photograph Collection, Indiana Geological Survey.)

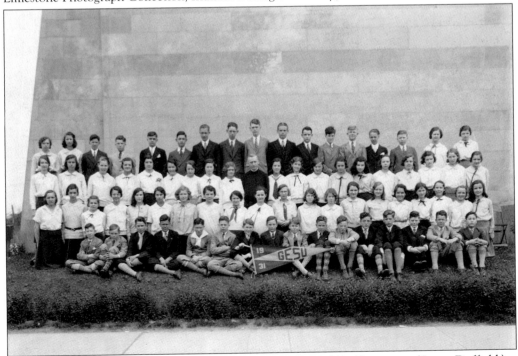

More than 70 students graduated from the eighth grade in 1931. (Courtesy of Larry Duffield.)

Irish immigrants Winifred and Pierce Butler were among Gesu's first parishioners. When Winifred bore a son in May 1922, Gesu founder Fr. John McNichols visited her hospital room and suggested naming the baby after the Jesuit founder, St. Ignatius Loyola. Christened James Ignatius Butler, the baby, who attended Gesu School, turned 95 in May 2017. James (on the left) is pictured with his brother Pierce. (Courtesy of James Butler.)

Margaret McManus played the organ in the Gesu farmhouse mission, the school basement chapel, and Gesu Catholic Church for more than 40 years. Father McNichols hired her to be Gesu's organist in 1924. She told the *Michigan Catholic* for Gesu's 60th anniversary in 1982 that she remembered how altar boys would put the chalice under the potbellied stove in the farmhouse church so the priest would not freeze his hands on the cold metal. (Courtesy of *Michigan Catholic*.)

Two

THE PARISH HOME

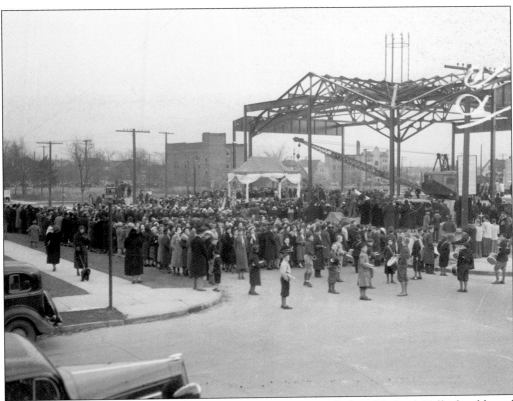

Gesu parishioners gathered on September 30, 1935, as Detroit bishop Michael Gallagher blessed the cornerstone for the new Gesu Catholic Church. The parish had outgrown the basement school chapel, but the Depression stalled construction of a church. The bishop's blessing was accompanied by a procession led by the Gesu Boy Scouts, the Drum and Bugle Corps, and the Young Ladies' Sodality. (Courtesy of Walter P. Reuther Library, Wayne State University.)

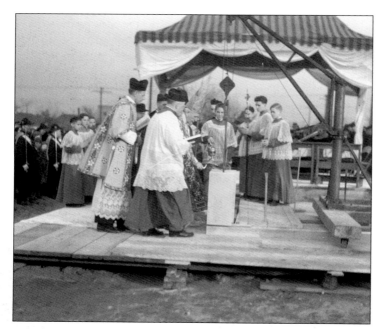

Bishop Gallagher, the Diocese of Detroit's bishop from 1918 to 1937, blessed the Gesu Catholic Church cornerstone as the Knights of Columbus stood watch. The cornerstone laying kicked off a five-day bazaar to raise money, with a raffle for a new car. Gallagher had presided over a 1920's building boom of churches and schools in the Detroit diocese before his death. (Courtesy of Walter P. Reuther Library, Wayne State University.)

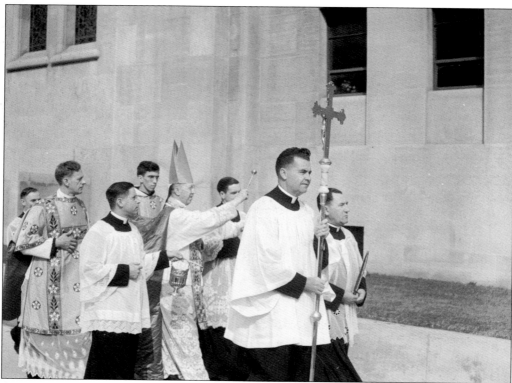

Gesu Catholic Church was dedicated on September 29, 1937, two years after the cornerstone was laid. New Detroit archbishop Edward Mooney sprinkled holy water around the limestone exterior of Gesu, the first church completed in the Detroit area since the Depression began, according to a *Detroit News* account. It was one of Mooney's first public acts since becoming Detroit bishop on May 31, 1937. (Courtesy of Walter P. Reuther Library, Wayne State University.)

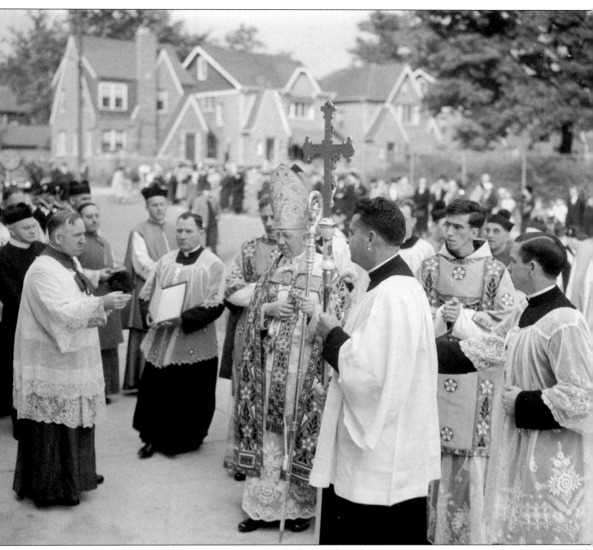

Crowds on Santa Maria Street awaited Detroit bishop Edward Mooney's entrance into the new Gesu Catholic Church on its dedication day on September 29, 1937. Mooney later was the first Detroit archbishop who received the red hat of a cardinal. As the population of southeast Michigan increased, Detroit became an archdiocese in the Catholic hierarchy. Pope Pius XII named Mooney a cardinal in 1946. Mooney died in 1957 from a heart attack shortly after arriving in Rome for the start of a papal conclave. Even before Mooney's dedication of Gesu, the church held its first Mass on August 15, 1936. The inaugural Mass featured "a new male choir of 40 voices . . . under the direction of Alex J. Pepin," the *Detroit Free Press* reported. Gesu's pastor, the Reverend Joseph Lannon, celebrated the Mass aided by other Jesuit priests, Fr. William Foley and Fr. Joseph Scott. (Courtesy of Walter P. Reuther Library, Wayne State University.)

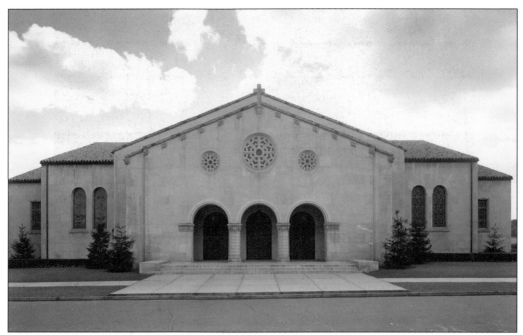

The new Gesu was built of Indiana limestone. Gesu parishioner and architect George F. Diehl designed the new house of worship in the Spanish modern style, to blend in with Gesu School and the architecture of the University of Detroit campus buildings. The parish and Detroit had grown quickly since Gesu's founding in 1922. Before the new church even opened, hundreds attended seven Masses each Sunday in Gesu School's basement chapel. Gesu's front exterior faced north on Santa Maria Street, across from a new, separate campus for the Catholic cloistered convent of St. Mary Reparatrix. (Both, courtesy of Manning Brothers Historic Photographic Collection, Detroit.)

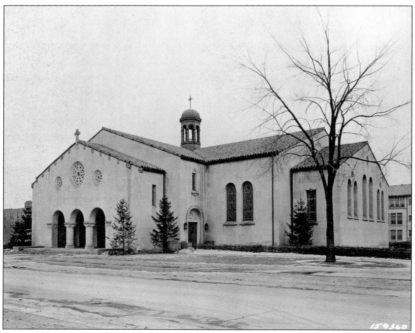

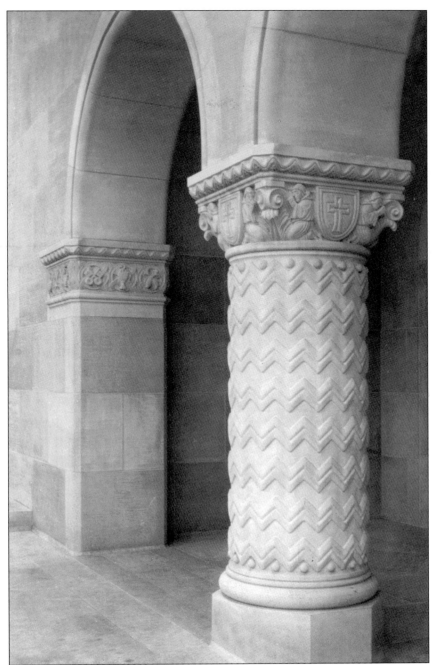

Gesu's front columns provide a distinctive entrance into the church. Corrado "Joe" Parducci, an Italian immigrant, sculpted the column designs that define Gesu's front facade. He also designed the door pendentives and other features inside the church. Parducci was one of the 20th century's noted architectural sculptors, famous for his work on Detroit landmarks, such as the Guardian Building and Masonic Temple, and the cast bronze Stations of the Cross at the National Shrine of the Little Flower Basilica in Royal Oak. Parducci also sculpted the much-loved Bear Fountain, formally known as the Horace H. Rackham Memorial Fountain, at the Detroit Zoo. (Photograph from the Diehl & Diehl Architects collection, courtesy of the Diehl family.)

Past the distinctive pillars of Gesu's entrance, the narthex provides cover from the elements. The narthex was an architectural element in the designs of many churches in early Christianity. A narthex acts as a gathering place or lobby before entering the church sanctuary. (Photograph by Robert W. Tebbs from the Diehl & Diehl Architects collection, courtesy of the Diehl family.)

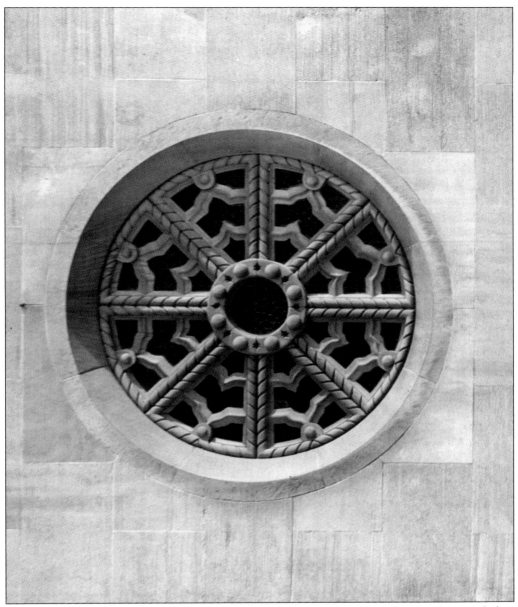

This stained-glass rose window punctuates the center point of Gesu's exterior. Gesu's stained-glass windows were designed by Detroit Stained Glass Works (DSGW). The firm was founded in 1861 as Friederichs and Staffin and was the first stained-glass manufacturer in Michigan. Architect George Diehl liked the designs for the Gesu windows but apparently did not like the cost. While DSGW manufactured the "blue" windows—which depict the Mysteries of the Rosary—for the church wall above the altar, Diehl took the DSGW's ornamental side window designs to a less expensive maker. This peeved DSGW owner Milton Irving, who years later was surprised to learn that his eldest daughter, Marie Josephine, was dating architect Gerald Diehl, son of Gesu architect George Diehl. Several years after they were married, Jo and Gerry Diehl moved into Gesu Parish. So did Milton Irving's youngest daughter, Mary Ellen, a window designer at the family business and wife of Henry Bellaimey. (Photograph from the Diehl & Diehl Architects collection, courtesy of the Diehl family.)

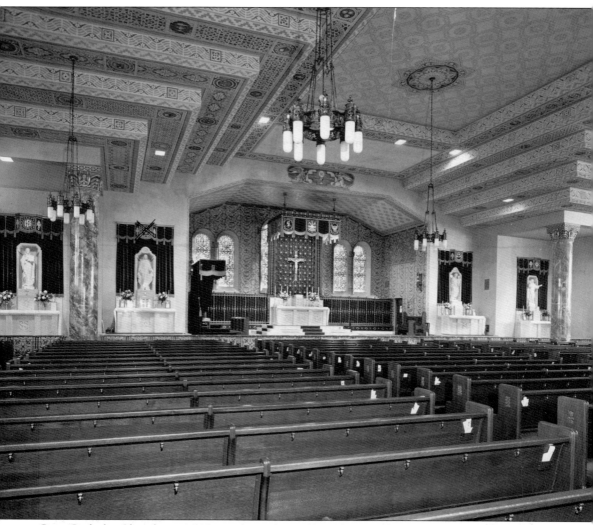

Gesu Catholic Church sat 1,500 people, and no pillars obstructed the congregation's view. The church was built twice as wide as deep, and the cost of the total construction was about $225,000. The stained-glass windows behind the main altar depict the Mysteries of the Rosary. Above the altar was a baldachino, or a canopy, to protect the altar that projected from the wrought iron reredos. The Gesu canopy was a maroon velvet brocade with gold embroidery. The gold embroidered medallions were rescued from the frayed original during the 1987 renovation and applied to new fabric in a new configuration, suspended over the more centrally located altar in use today. (Photograph from the Diehl & Diehl Architects collection, courtesy of the Diehl family.)

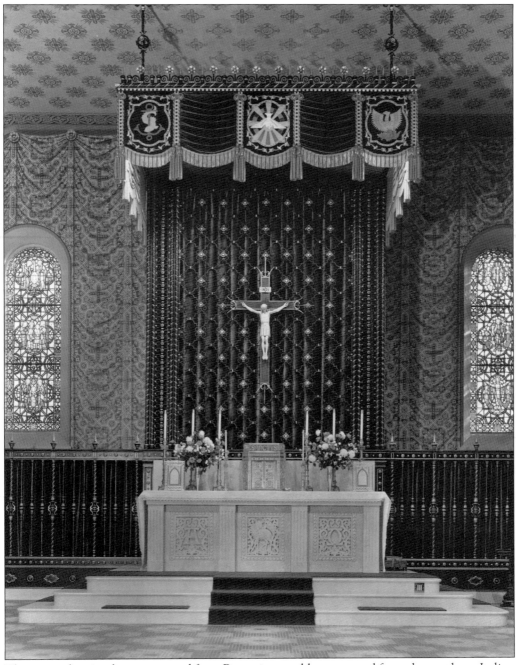

The original main altar was carved from Bottocino marble, excavated from the northern Italian province of Brescia. Saintly relics are embedded in Gesu's altar stone. Included among them is a relic of St. Francis Xavier, a Jesuit missionary and cofounder of the Jesuit order. It is to remind parishioners of their Catholic mandate to spread the gospel, as Francis Xavier did when he was the first Christian missionary to Japan. Another relic is from St. Irenaeus, an early theologian who stressed Scripture and tradition. When Gesu was renovated in 1987, the original altar was downsized and parts of the marble were incorporated into the features of the church's redesign. (Photograph from the Diehl & Diehl Architects collection, courtesy of the Diehl family.)

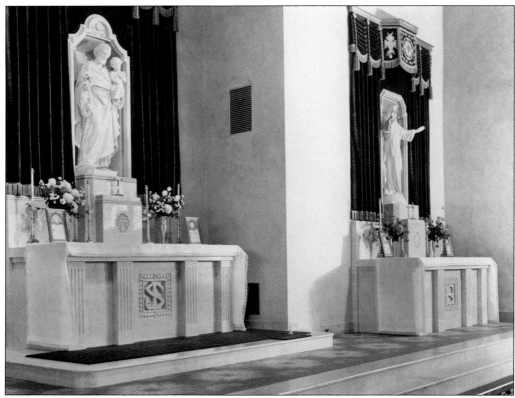

The two side altars on Gesu's east flank (below) as initially built were of St. Ignatius Loyola, founder of the Jesuits, and Mary, the Blessed Mother. The west side altars (above) featured statues of St. Joseph, who holds a baby Jesus in his arms, and of the Sacred Heart of Jesus. (Both, photograph from the Diehl & Diehl Architects collection, courtesy of the Diehl family.)

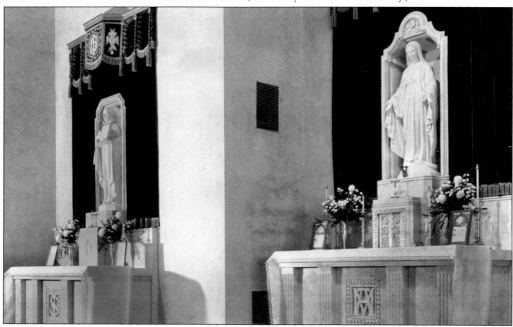

Wrought iron was used for the communion railing, the sanctuary railing, and for the reredos, which is a backdrop for the main altar. It was the work of Jack Moynahan. The decorative rosettes were hand-wrought. In the 1987 church renovation, the communion railing was repurposed in decorative ways. Railing pieces were used again in 2017 to accent a new baptismal pool. (Photograph from the Diehl & Diehl Architects collection, courtesy of the Diehl family.)

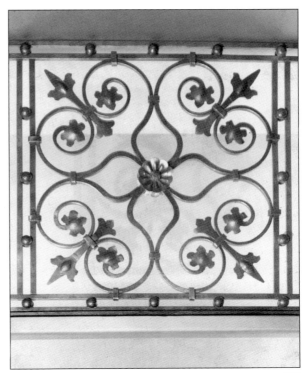

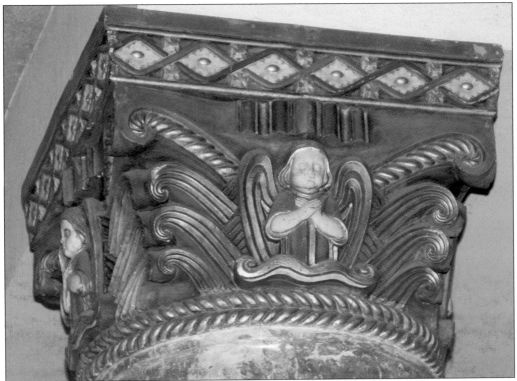

A gilded cherub and colorful scrollwork adorn the capitals crowning two scagliola columns flanking the altar. (Photograph by James Eddy.)

In 1938, Gesu's pastor, the Reverend Father Thomas Moore, and architect George Diehl presented plans for a new convent to IHM Mother General, Mother Ruth, in Monroe. The Gesu Sisters had lived in three rented houses on adjacent Quincy Street for years. In the Gesu convent chronicles, it is noted that newcomers became confused about room assignment and "human question boxes" asking "which house am I in now?" Here is one architectural rendering of the convent. Ground-breaking for the new convent was on August 30, 1938, and in March 1939, some 20 Sisters moved in. The convent is now Gesu's Parish Center and home of the parish offices. The convent chapel is still in use and is where weekday Masses are held during the colder months. (Above, courtesy of Gesu Parish Archives; below, courtesy of Manning Brothers Historic Photographic Collection, Detroit.)

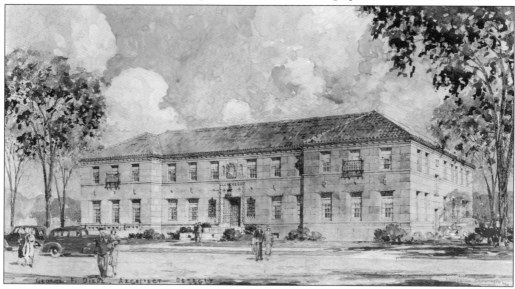

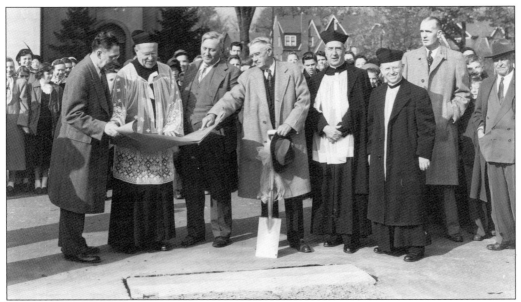

Gesu's pastor, Fr. Edward Holton, second from left, presided over a ground-breaking for Gesu's new rectory and parish offices in October 1949. Flanking him are architect George Diehl on the left and Frank Brennan, a superintendent with the W.E. Wood construction firm, on the right. The Brennan family was long involved in Gesu building projects. Frank's father, Henry Brennan, was a Wood company co-owner and had 30 grandchildren, 19 of whom attended Gesu School. (Both, courtesy of Gesu Parish Archives.)

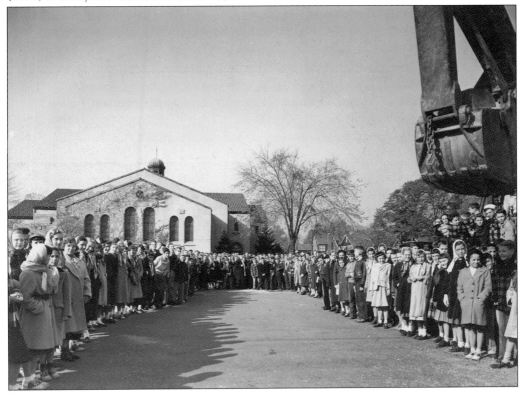

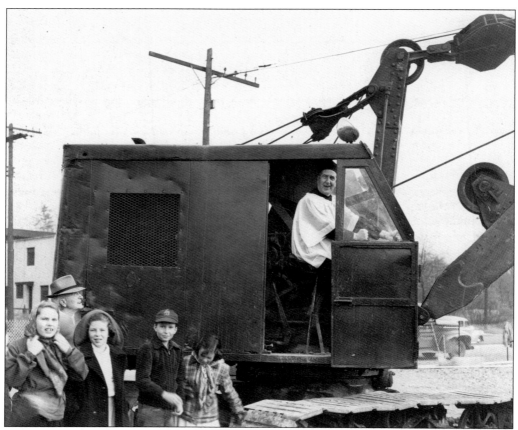

Surrounded by Gesu seventh and eighth graders who had been let out of school, the Reverend William Foley takes control of the steam shovel to prepare for the new rectory. Foley arrived at Gesu in the 1930s and stayed for decades. He was editor of the *Gesu News* for 36 years and noted in the October 30, 1949, edition that the parish's building committee deserved thanks for the new rectory. The building committee's chairman was industrialist A.J. "Alfred" Fisher, one of the seven Fisher brothers who established Fisher Body and erected Detroit's iconic Fisher Building. Many of the Fisher brothers' children attended Gesu School. (Above, courtesy of Gesu Parish Archives; below, photograph by Elmer C. Astleford from the Diehl & Diehl Architects collection, courtesy of the Diehl family.)

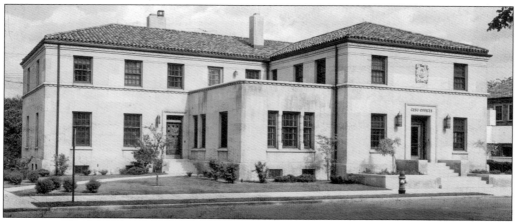

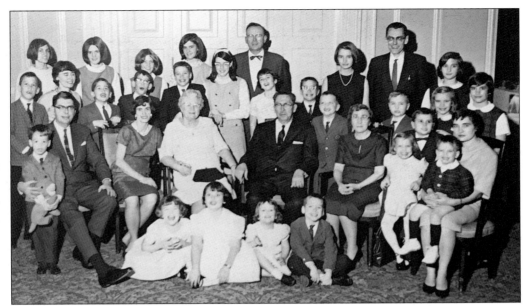

Seated center front is architect George F. Diehl, who designed much of the Gesu Parish campus as well as the church and convent. With his eldest son, Gerald G. Diehl, seated front row left, he formed Diehl & Diehl Architects and designed the rectory and the Gesu school gymnasium addition. Of George F. Diehl's 27 grandchildren, 15 graduated from Gesu School. (Courtesy of the Diehl family.)

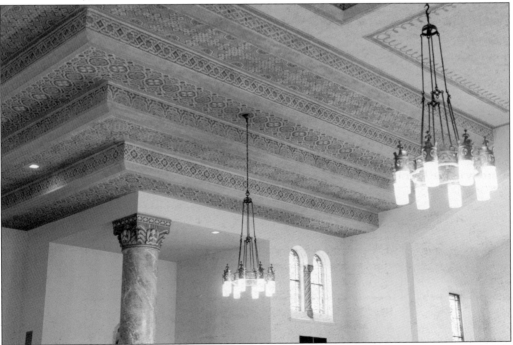

Sometime after Gesu Catholic Church was completed, parish benefactors from the Fisher family underwrote the hiring of expert painters and muralists to create a more artful, decorative ceiling and back wall. The Spanish Mission–style influence, with Moorish undertones, is visible in the ceiling's artistry. (Photograph by Mae Stier.)

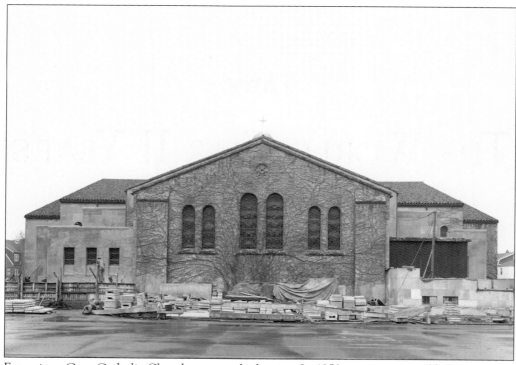

For a time, Gesu Catholic Church was enrobed in ivy. In 1950, a renovation added more space for a bigger sacristy and bathrooms at the back sides of the church. The architect was George F. Diehl. (Photograph by John Snyder, courtesy of Gesu Parish Archives.)

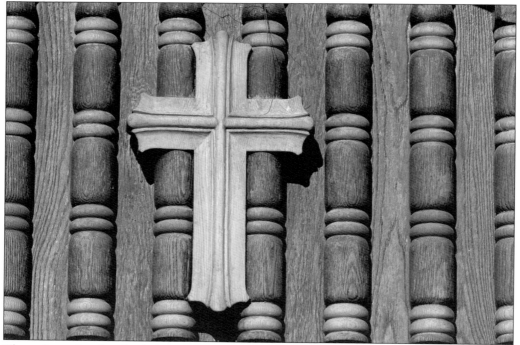

Throughout the church, there are eye-catching symbols. In the arch above the back side doors is a colorfully crafted cross. (Photograph by Diane Weiss.)

Three

THE WORLD WAR II YEARS

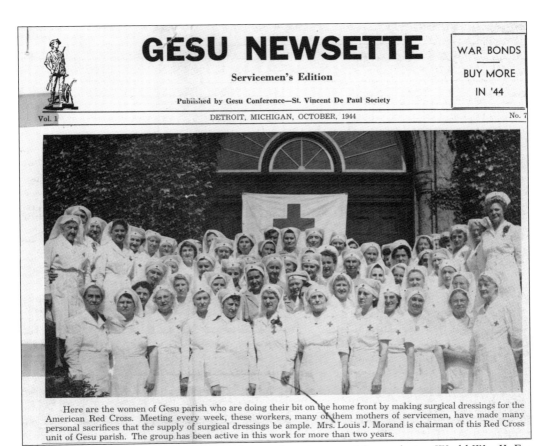

GESU NEWSETTE

Servicemen's Edition

Published by Gesu Conference—St. Vincent De Paul Society

Vol. 1 DETROIT, MICHIGAN, OCTOBER, 1944 No. 7

WAR BONDS
—
BUY MORE
IN '44

Here are the women of Gesu parish who are doing their bit on the home front by making surgical dressings for the American Red Cross. Meeting every week, these workers, many of them mothers of servicemen, have made many personal sacrifices that the supply of surgical dressings be ample. Mrs. Louis J. Morand is chairman of this Red Cross unit of Gesu parish. The group has been active in this work for more than two years.

More than 1,000 members of Gesu Parish served in the armed forces during World War II. For them and their families, the parish produced the *Gesu Newsette: Servicemen's Edition*. This October 1944 issue, a portion of which is seen here, features 70 American Red Cross volunteers from the parish, led by Helen Morand. The issue also includes a list of participants in a recent parish blood drive and updates about a parish member missing in action in the South Pacific. (Courtesy of Gesu Parish Archives.)

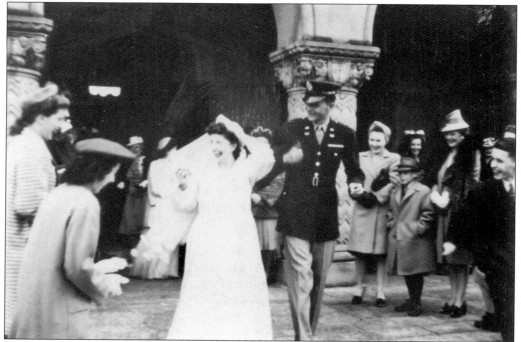

Wartime weddings featuring grooms in uniform happened often at Gesu. After marrying Army second lieutenant Robert Duffield at Gesu in 1943, Gesu alumna Maureen Sheahan is showered with rice and framed by the church's columns. The couple later bought a house nearby and their five sons—Tom, Dick, Harry, Bob, and Larry—all graduated from Gesu School. (Courtesy of Robert Duffield Jr.)

At home, there were other worries in addition to the war. The school's opening was delayed a week in September 1944 because of an outbreak of polio. But in January 1945, the IHM Sisters rejoiced because a public address system was installed at school. In May, 144 Gesu students received their First Communion and posed with the Reverend Peter O'Brien. (Courtesy of Manning Brothers Historic Photographic Collection, Detroit.)

The Gesu altar boys and the Gesu Boys Choir pose on the church altar for their 1944–1945 year photographs, along with associate pastor Fr. Peter O'Brien. (Both, courtesy of Manning Brothers Historic Photographic Collection, Detroit.)

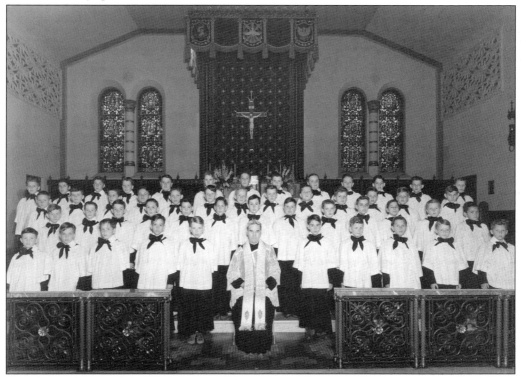

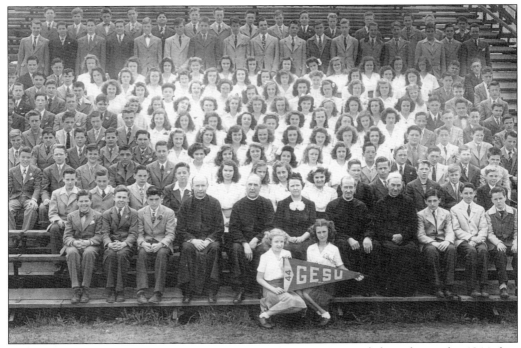

Gathered on bleachers on the University of Detroit campus, Gesu eighth graders took a 1944 class photograph. The woman in the front row is Ella Roy, an eighth-grade teacher. On her immediate left is Fr. William Foley, and to her right are Fr. Thomas Moore, pastor, and Fr. Peter O'Brien, associate pastor. (Courtesy of Gesu Parish Archives.)

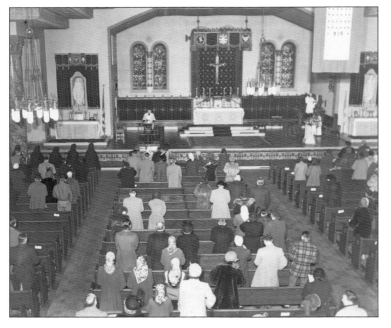

A service banner, seen here in the upper right corner, indicates that 914 parishioners were in the armed forces at the time. Gold stars represented Gesu parishioners who had died in service to their country. Troops quartered nearby at the University of Detroit used Gesu facilities for a mess hall during the war. (Courtesy of University of Detroit Mercy Archive and Special Collections.)

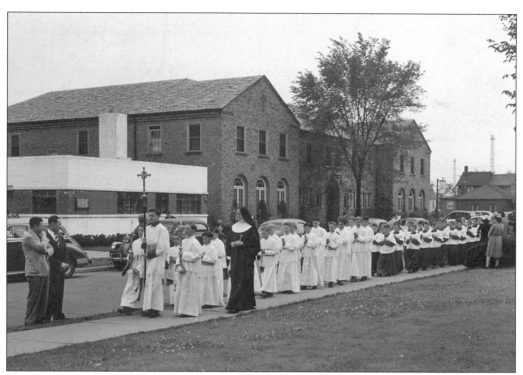

For the May Crowning of the Blessed Mother, the whole school turned out for the procession to the church. The second graders wore their First Communion finery. (Both, courtesy of Gesu Parish Archives.)

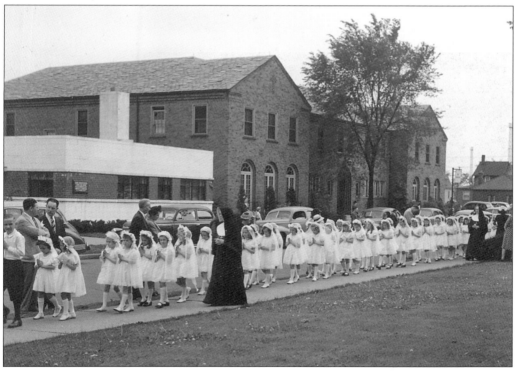

FATHER MOORE'S V-E DAY MESSAGE

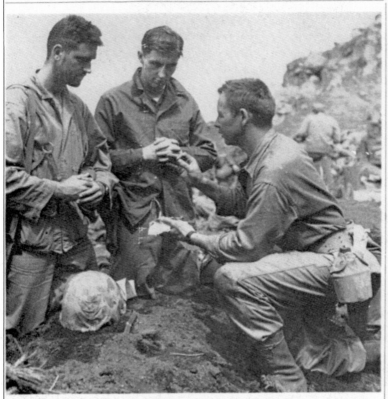

The long-awaited V-E Day is here. It is a day that gives us the assurance that God is with us and has carried us through the long years, in which we have suffered and endured, both on the battle front and on the home front, in order that the false philosophy of a selfish soul, that would rule God out of the hearts of men, might be wiped out and that peace and understanding might reign among the nations of the earth. For all of us these days should be days of prayer: a prayer of thanksgiving to Almighty God for the successful termination of the European war; a prayer that God will show us the same kind Providence in the Pacific conflict and bring it to a speedy and happy end for us, a prayer for all our boys in the service that God may keep them true to the principles of their Faith; a prayer for bereaved parents that God may give them the comfort which He alone can give; a prayer for our boys who have given their lives that liberty might endure; a prayer for our country that the spirit of our Founders may prevail and keep us conscious of our responsibility........... "Lest we forget, lest we forget."

Your Gesu Pastors

A picture that speaks louder than words is this one taken on Iwo Jima by a marine photographer during the invasion. And the two boys receiving Holy Communion are Gesu school products, U. of D. High alumni and university students—the King brothers, sons of Mr. and Mrs. Cyrus King of Covington Drive. Capt. William J. King (left) is a veteran of several invasions with the Marines and his brother, Ensign George E. King (center) has been with the navy in the South Pacific. It was during Iwo Jima invasion Ensign King came up with some supplies and he learned his brother was only a few miles away near the front lines. Just as they meet, Father Lawrence Calkins, a Servite from Chicago, came along to distribute Communion to the fighters. Ensign King asked permission to receive with his brother.

(Courtesy The Michigan Catholic)

Pro Dio; Pro Patria

"And you wonder how much longer you can dodge death," wrote Cpl. Clarence Blaesser of Fairfield avenue on Holy Saturday from "somewhere on the Rhine." And a week later he received his summons to his Master while fighting with the infantry. But he was ready for in the same letter he wrote:

"Tomorrow is Easter Sunday and it is my fourth away from

(Continued on page four)

The May 1945 *Gesu Newsette* features a photograph of two brothers, Marine captain William J. King and Navy ensign George E. King, receiving Holy Communion when they encountered each other in the invasion of Iwo Jima on the Pacific. The Gesu and University of Detroit High alumni received the sacrament from Servite father Lawrence Calkins. The *Gesu Newsette* featured letters from parish members serving across the world. Parish staffer Helen O'Brien, herself a war mother, collected the information and urged families to send the *Gesu Newsette* to their sons (and at least one daughter) who served in the military. This edition has a message from Gesu pastor Thomas Moore: "For all of us these days should be days of prayer: a prayer of thanksgiving to Almighty God for the successful termination of the European War; a prayer that God will show us the same kind of Providence in the Pacific conflict . . . a prayer for bereaved parents that God may give them the comfort which He alone can give; a prayer for our boys who have given their lives that liberty might endure." (Courtesy of Gesu Parish Archives.)

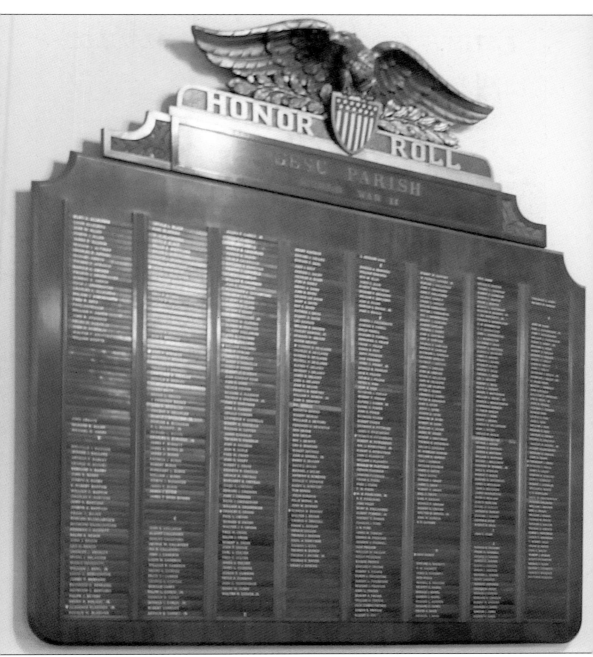

The May 1945 issue of the *Gesu Newsette* also brought heartbreaking news—the death of parishioner Cpl. Clarence Blaesser. There also was a notice for the funeral Mass at Gesu of Pfc. George McFalda, killed in Czechoslovakia on his 31st birthday. And there was word that Francis J. McCarthy, one of the three service sons of parishioners Mr. and Mrs. Frank J. McCarthy, was missing in action. After the war, Gesu Parish installed two memorials in the church that list the names of parishioners who served their country during World War II. Each buffed wood wall hanging is nearly six feet across to contain the names of all Gesu parishioners who served. Gold stars indicate those who did not return alive to Gesu Parish. The gold stars still shine next to the names of Blaesser, McFalda, and McCarthy. (Photograph by Diane Weiss.)

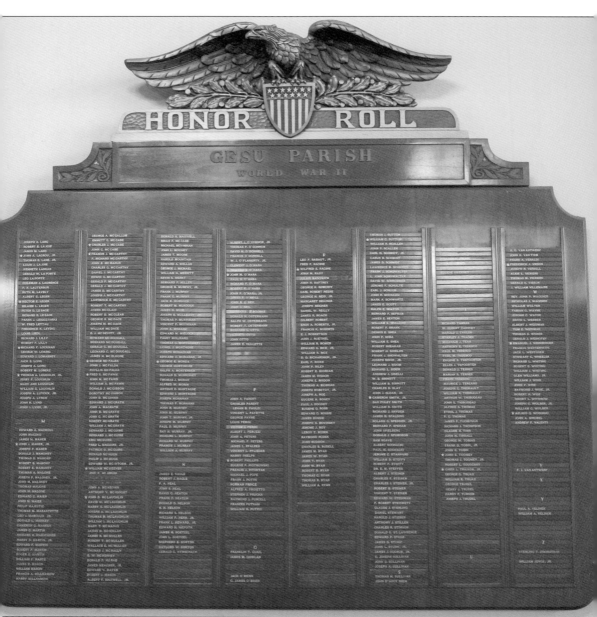

Infantryman Clarence Blaesser's last letter was reprinted in the May 1945 *Gesu Newsette*. "And you wonder how much longer you can dodge death," wrote Corporal Blaesser, of Fairfield Avenue, on Holy Saturday in 1945 from "somewhere along the Rhine." It was his fourth Easter Sunday in service, and he noted, "I wonder if maybe I'll be lucky enough to spend my next one home." After a Holy Thursday Mass in a German cathedral during an Easter holiday cessation of combat, Blaesser wrote that "it seemed strange to be hearing Mass kneeling right alongside of German civilians. Both praying to the same God. The Germans probably praying for their son's safety; the Americans for their own safety and for their families, and yet we'll soon be on a battle field slugging it out with these same German sons." A requiem Mass was offered for Blaesser at Gesu Catholic Church on April 30, 1945. His name is one of 34 names on the Gesu memorial adorned with a gold star. (Photograph by James Eddy.)

Four

GESU BOOM YEARS

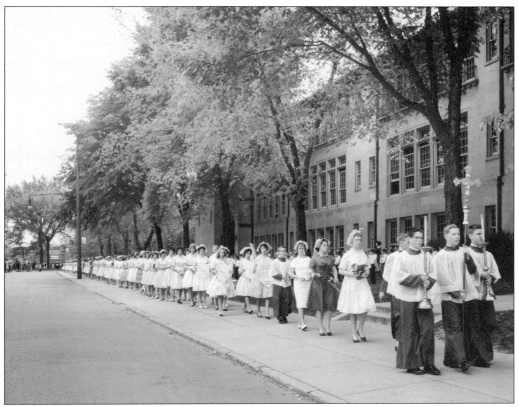

During the 1950s and 1960s, Gesu School was bursting with the baby boomer offspring of huge families. The neighborhood around Gesu was a mix of prosperous and middle-class homes and equally split among Catholic, Jewish, and Protestant families. Traditions such as the 1961 May procession stopped traffic and were an annual delight. (Photograph by Elaine Studio, courtesy of Gesu Parish Archives.)

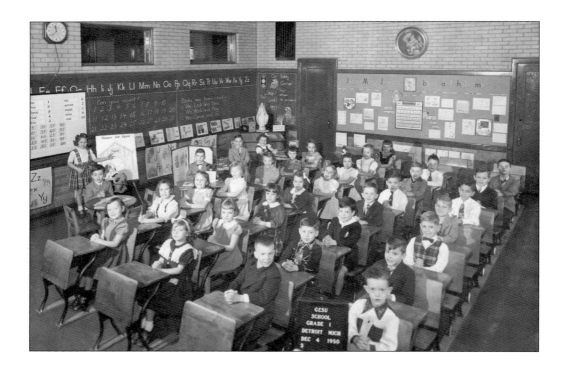

Why are these students smiling? It is picture day for a classroom of Gesu first graders and one of seventh graders in 1950. (Above, courtesy of Robert Kolinski; below, courtesy of Gesu Parish Archives.)

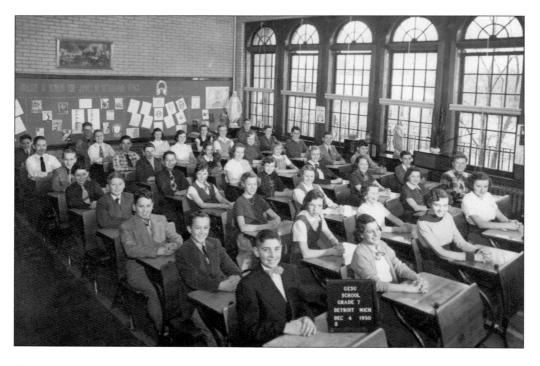

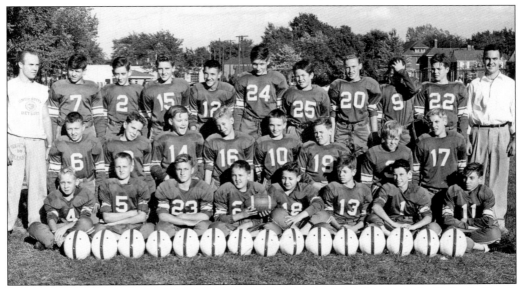

Pictured is the 1951–1952 Gesu football team. Gesu had recorded a citywide Catholic Youth Organization (CYO) football championship in 1948. Gesu sports teams initially were known as the Panthers but eventually were named the Giants. (Courtesy of Don Bridenstine.)

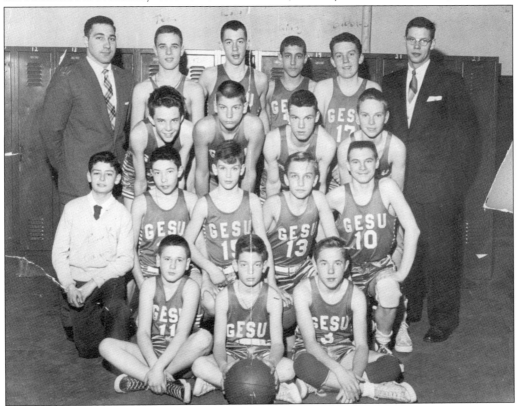

Team members of a mid-1950's basketball squad pose with their coaches. Gesu also had a large intramural basketball program, and the intramural squads were named after Jesuit universities. The school's large gym was completed around 1952. (Courtesy of William Schneider.)

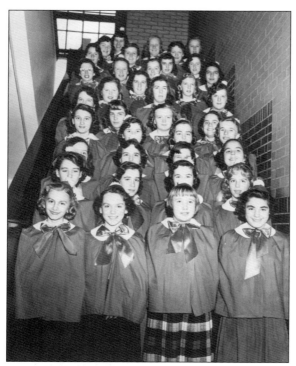

The Gesu Girls Choir is decked out in red Christmas capes. The girls entertained the downtown Detroit crowds in December 1952 at Grand Circus Park. Out-of-towners staying at a nearby hotel called the *Detroit Times* to find out who was providing the entertainment. (Courtesy of Gesu Parish Archives.)

Ella Roy was one of the first lay teachers at Gesu. When the Upper Peninsula native celebrated 25 years at the school in 1954, students got a free day, the *Detroit Free Press* reported. She taught eighth grade at Gesu and retired in the early 1960s after 31 years of service. (Courtesy of Gesu Parish Archives.)

Gesu School's coveted Dorais Award was bestowed upon eighth grader Paul Dingeman in 1956 as the top Safety Patrol boy. The award honored David Dorais, a Gesu student who drowned in 1947; he was the son of University of Detroit and Detroit Lions coach Gus Dorais. (Courtesy of Gesu Parish Archives.)

HONORED F°R COURAGE

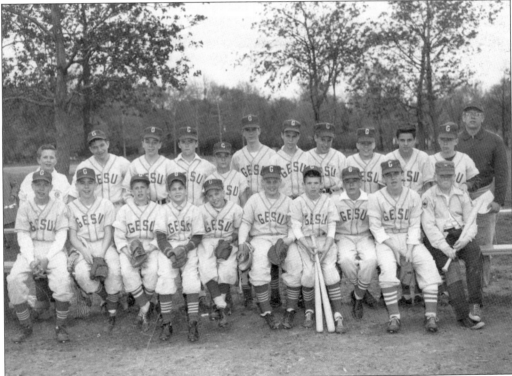

In the mid-1950s, Gesu expanded its athletics program and activities. Pictured is a Gesu baseball squad from the late 1950s. Students gave testimonials to the *Gesu News*. "The expansion of the athletic activities will do much to prevent possible turning of many children to less clean and wholesome outlets for their energies," one student wrote. (Courtesy of Robert Kolinski.)

Girls from the eighth grade were selected to be in the court for the May Crowning. The honor of crowning the statue of the Blessed Mother Mary went to Mary Kehoe in 1959. (Photograph by Pieronek Studios, courtesy of Gesu Parish Archives.)

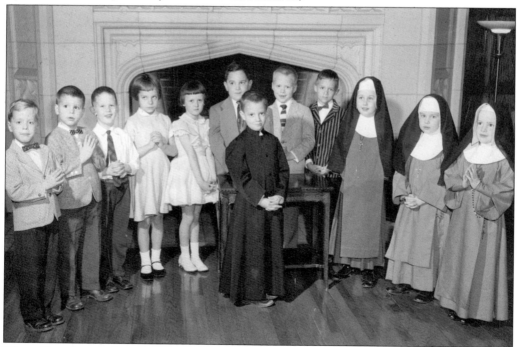

These Gesu first graders are dressed up as priests and the Catholic nuns who taught them, as part of the 1959 *Vocation Playlet*. The performance's intent was to encourage a calling to religious life. (Photograph by Pieronek Studios, courtesy of Gesu Parish Archives.)

Instead of dressing up as ghosts and goblins for Halloween, many Catholic school students were encouraged to dress as saints. At Gesu in the early grades, students donned garb to honor their namesake saints. (Above, courtesy of Paul Rossiter; below, courtesy of Bob Duffield.)

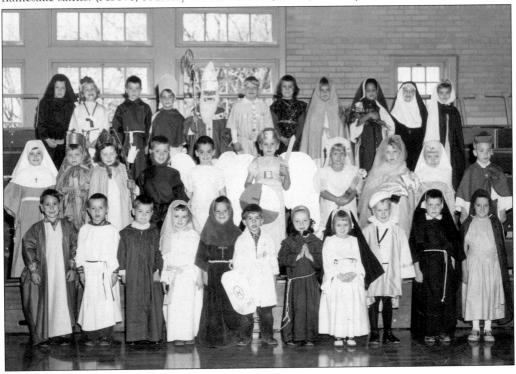

The 1962 Gesu graduating class was captured in separate photographs for boys and girls. It was rare to see an IHM nun in a photograph because their superiors discouraged them from having pictures taken. That changed a few years later as Gesu reached peak enrollments of nearly 1,600 students, and the modern changes spurred by Vatican II reforms took effect. The Gesu School cafeteria is now decorated with many composites of graduating classes. The IHM Sisters started appearing in class photographs around 1967, still in full habits. By 1970, many IHM Sisters at Gesu had adopted modern dress. (Both, photograph by Richard J. Klein, courtesy of Gesu Parish Archives.)

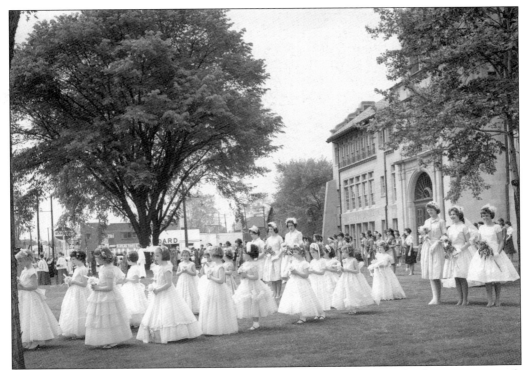

The 1961 Gesu May Crowning procession was a precision-timed event. Student groups—such as Scouts, Campfire Girls, and second graders in their First Communion garb—were positioned around the school, awaiting directions to fall into line. Inside the church, an eighth-grade girl placed the crown on a statue of Mary, the Blessed Mother of Jesus. (Both, photograph by Elaine Studios, courtesy of Gesu Parish Archives.)

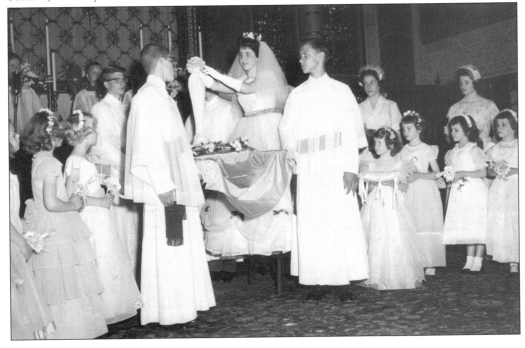

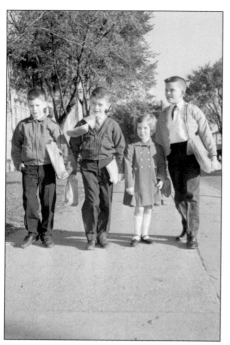

Jerome "Jerry" Cavanagh was Detroit mayor from 1962 to 1970 and a Gesu parish parishioner. His eight children received a fair share of press attention. A morning walk to Gesu School by the four eldest Cavanagh children around 1964 was photographed for a *Detroit News* feature about the mayor's family. Pictured on Oak Drive are, from left to right, siblings Patrick, David, Therese and Mark Cavanagh. When the seventh Cavanagh child, Jerome Celestin, was baptized at Gesu in April 1963, the *Detroit Free Press* covered it. (Courtesy of Walter P. Reuther Library, Wayne State University.)

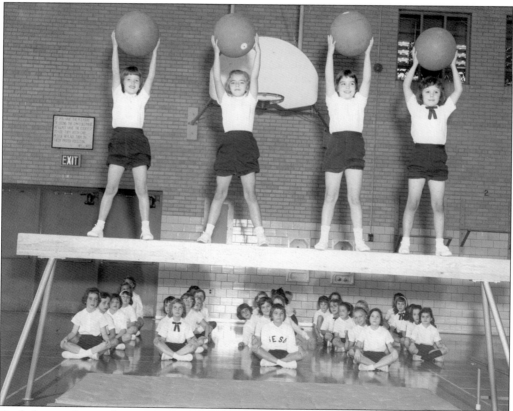

On balance, Gesu girls got a workout during gym class. (Photograph by Arthur Hilton, courtesy of Gesu Parish Archives.)

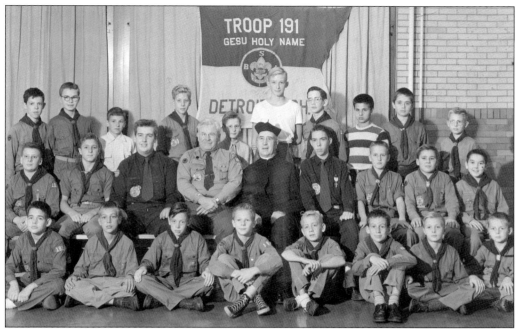

Gesu's Scouting program for boys dates back to the parish's earliest days and is one of the oldest in Detroit. Fr. William Foley helped promote the program and was acknowledged with national awards as one of the longest-serving Boy Scout chaplains in the United States. Through the early 1980s, the troop produced more than 50 Eagle Scouts. Girl Scouts came to Gesu in the 1940s. Gesu's Scout House on Oak Drive, on the school's eastern flank, was demolished in the early 2000s to make way for the Gesu Community Green playscape. (Above, photograph by John David Snyder, courtesy of Gesu Parish Archives; below, courtesy of Richard Hirneison.)

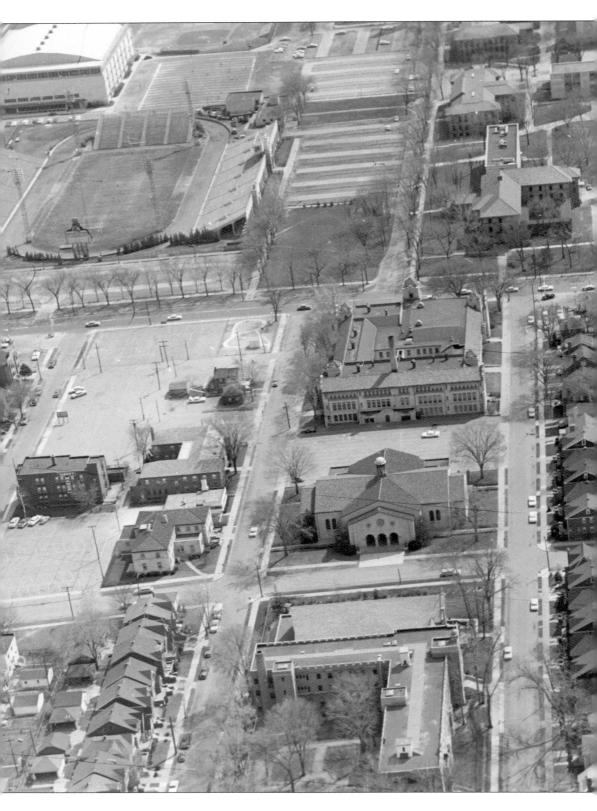

This undated photograph provides an aerial view of the Gesu Parish campus, just northeast of Livernois Avenue and McNichols Road in northwest Detroit, as it stood in the 1960s. In the top half of the photograph are the University of Detroit (UD) campus and its football stadium. UD dropped its football program in 1963, prompting students to shut down part of a nearby freeway in protest. The stadium was demolished in 1971. Just north of Gesu Catholic Church, there is a cloistered convent for the nuns of St. Mary of Reparatrix. The convent is now home to an Italian order of priests, the PIME Missionaries. The small square house south of the Gesu convent was the Scout House. The house and adjacent structure were demolished and a community green with a playscape was built in 2001, giving neighborhood youngsters a safe place to play. The doctor's office between the convent and the rectory has been torn down, as has the old Birchcrest Hotel, used for a time as university housing. (Courtesy of Gesu Parish Archives.)

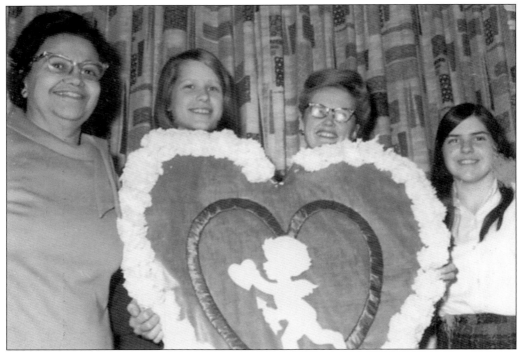

The Gesu Girl Scouts helped put on the 25th Annual Valentine Party for the Gesu Sacred Heart League in 1967. In charge of the decorations were Mrs. Sam Morganroth, left, and Mary Kay Roddy, second from right. Girl Scout Cadettes Karen Smith and Linda Rittersdorf display the decorative Cupid. (Courtesy of Linda Rittersdorf Keimig.)

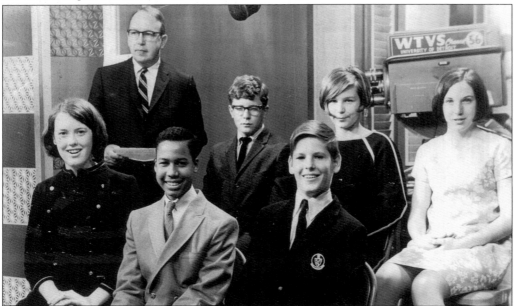

In 1968, several eighth graders were selected to be part of a television program being filmed. Their host was William Cahalan, Wayne County prosecutor and himself a Gesu parishioner and parent. The Gesu students are, from left to right, (first row) Kathy Quinn, Claud Young, and Steve Palid; (second row) Mark Bauer, Joyce Angel, and Ann Reno. (Courtesy of Mark Bauer.)

Five

FAITH IN DIVERSITY

These Gesu students bring up the offertory gifts at Mass around 1982. Through the 1970s and beyond, Gesu School rapidly integrated. The period brought daunting challenges to the parish and school. From 1970 to 1980, Detroit lost 20 percent of its population, as white residents, many of them Catholics, moved out of the city. (Courtesy of Gesu Parish Archives.)

This 1973 photograph of Gesu School accompanies a *Detroit Free Press* story exploring integration in the University District and Golf Club neighborhoods around the parish. By 1977, Gesu's enrollment was about 1,000 students, evenly split between black and white. There also was a debate in the parish about the large presence of non-Catholics in the school—many black students were of other Christian faiths. In the baby boomer years, it was not unusual for Gesu families to have six, eight, or a dozen kids. But as Gesu became less a parish of younger families, Gesu leaders remained committed to keeping the school open, even as many Detroit Catholic schools shut down. In 1966, Gesu School hired its first African American teacher, Tinney Barnes, now a parishioner for more than 50 years. Her daughter, Gesu alumna Anita-Joyce Barnes, notes: "We have seen the parish transform from a predominantly white parish in a predominantly white neighborhood to the diverse parish that it is today—with a greater sense of serving the community." (Photograph by Richard Hirneisen.)

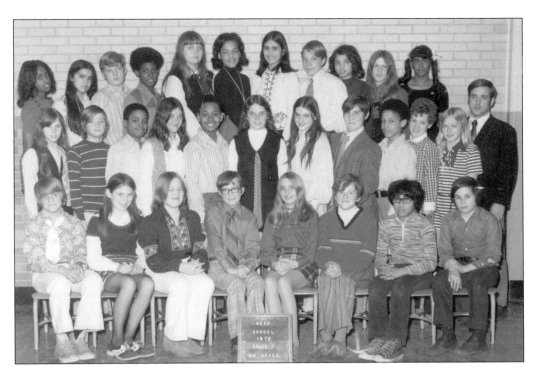

These classroom photographs from 1972 are a snapshot in time. In 1972, Gesu parish celebrated its 50th anniversary. Gesu School enrollment was about 1,200 students, down about 400 from its peak. Above, seventh graders pose with teacher Lou Offer, a Gesu alum himself. Below, Sister Anna and Kay Storen smile with their third-grade students. (Above, courtesy of Mike McElhone; below, courtesy of Ame Blaine.)

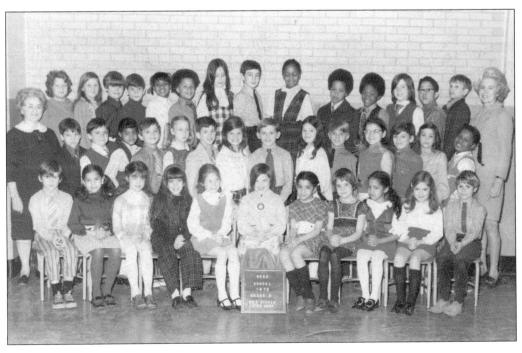

Sixth graders in homeroom 310 performed "Seventy-Six Trombones" in the 1971 spring musical *Happiness Is*. Another sixth-grade class, homeroom 307, sang "The Happy Wanderer." (Courtesy of Mike McElhone.)

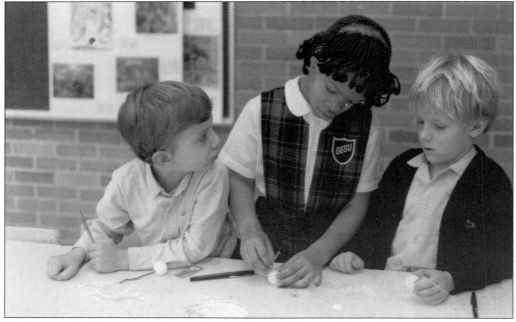

Students in this Gesu trio work together to solve a problem in this mid-1980s photograph. Gesu student enrollment hovered near the 1,000 mark for much of the 1970s and 1980s. (Courtesy of Marie Handley.)

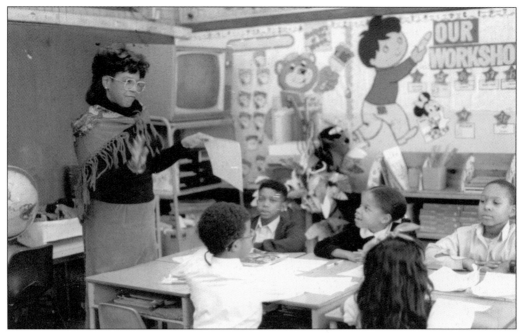

Tinney Barnes was the first African American teacher at Gesu and retired in 2002 after 36 years. She taught legions of second- and third-grade students. One parent wrote her in June 1970, thanking Barnes for finding innovative ways to teach a son with reading problems and making his school year "a pure joy." (Courtesy of Anita-Joyce Barnes.)

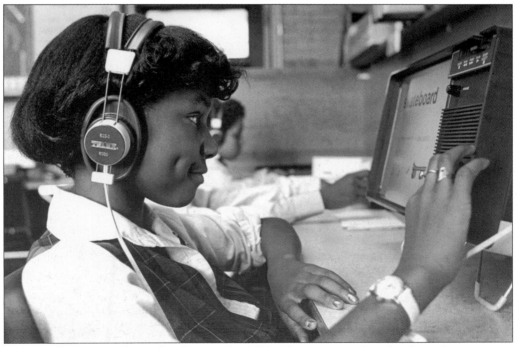

The digital age was welcomed to Gesu in the 1980s. Keeping up with technological innovations has been a priority for Gesu School, and its computer room was updated and modernized in 2013. (Courtesy of Gesu Parish Archives.)

If a teacher told a student to go sit in the hall at Gesu, it was a good thing. It meant the student had earned time to read a book of his or her choosing amidst friends. The Gesu School floor tiles are believed to be from the Flint Faience & Tile Co., established in 1921 when Albert Champion realized that the kilns used to make porcelain caps for General Motors spark plugs could work at night to make tiles. (Courtesy of Gesu Parish Archives.)

"You must listen in order to learn," teacher Sarah "Nikki" Henold told her young students in a Gesu classroom in 1982. In the 1980s, Gesu had programs aimed at gifted and special education students. (Courtesy of Gesu Parish Archives.)

Sister Patricia O'Donnell was a longtime legend at Gesu. Once known as Sister Generosa, she taught eighth graders from 1972 to 2004. She also worked at Gesu School as its finance director. (Courtesy of *Michigan Catholic*.)

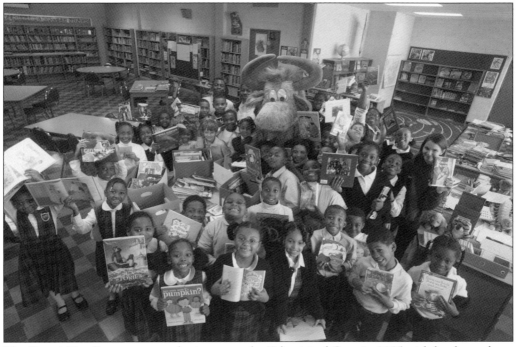

The *Detroit Free Press* young readers' mascot, the Yak, visited Gesu in 2005 with books students won for the school library. (Photograph by Jerry Mendoza, courtesy of *Detroit Free Press*.)

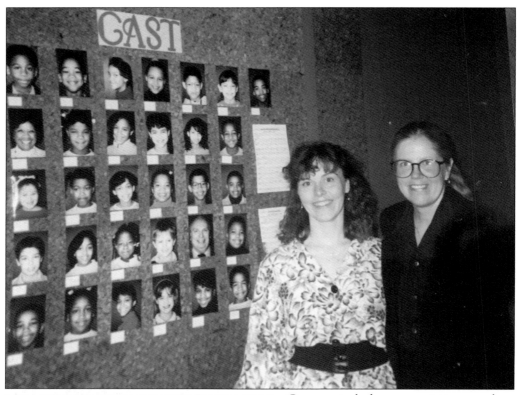

Gesu musicals drew appreciative crowds. Teacher Suzanne McGill, left, directed a dozen musicals. Here, she is pictured with teacher Kathleen Samul and cast photographs from *Hello, Dolly!* Teacher Tinney Barnes played Dolly. (Courtesy of Suzanne McGill-Anderson.)

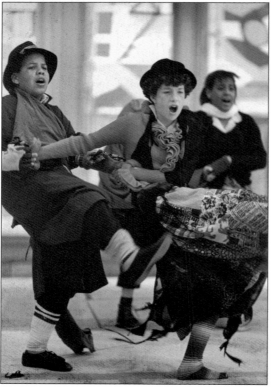

The *Michigan Catholic* featured this high-spirited moment from Gesu rehearsals for *Annie* in 1986. (Photograph by Dwight Cendrowski, courtesy of *Michigan Catholic*.)

Student Susan Matous played Annie in Gesu's 1986 production, and Fr. James Serrick played Pres. Franklin Roosevelt. (Courtesy of Marie Handley.)

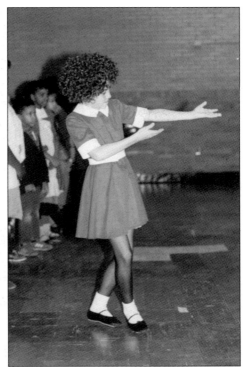

From left to right, Kamia Hicks, Brian Marable (as Jesus), and Terique Smith rehearse for Gesu's production of *Godspell* in 1989. (Photograph by Ted Berlinghof, courtesy of *Michigan Catholic*.)

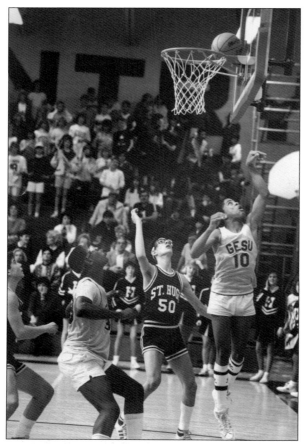

Gesu athletic teams have won multiple Catholic Youth Organization (CYO) city championships over the years. The photograph at left captures a moment from a Gesu basketball game in March 1986 against St. Hugo in Bloomfield Hills. Gesu varsity boys' basketball teams won CYO championships in 1984, 1985, and 1986. Gesu girls' basketball won CYO championships in 1961 and 1962. The Gesu football team won a CYO championship in 1948. Gesu cheerleaders were CYO competition finalists eight times between 1990 and 2000. (Left, courtesy of *Michigan Catholic*; below, courtesy of Gesu Parish Archives.)

Six

THE IHM SISTERS' LEGACY OF SERVICE

Nearly 300 nuns from the Sisters, Servants of the Immaculate Heart of Mary (IHM) congregation have staffed Gesu School. Sister Stella Rabaut, second from left, was Gesu principal from 1971 until 2000. She is photographed here with her siblings and their parents. From left to right are Sister Celeste Rabaut, Sister Stella Rabaut, Stella Rabaut (mother), US representative Louis Rabaut (father), Sister Martha Marie Rabaut, and Rev. Dermott Rabaut. Congressman Rabaut long represented Detroit's east side and is credited with first introducing legislation to insert "under God" into the Pledge of Allegiance. (Courtesy of Gesu Parish Archives.)

On the left in this undated photograph is Sister Adele DuRoss, who taught lower grades at Gesu from 1939 to 1946 and returned as principal from 1968 to 1971. She is with Sister Dolora Neumaier, who was assistant principal from 1968 to 1971. (Courtesy of Gesu Parish Archives.)

Sister Agnes Therese Bailey returned to Gesu for the parish's 50th anniversary in 1972. She taught kindergarten at Gesu from 1956 to 1969, including one year when her class was located at nearby Marygrove College. She also had taught at Gesu from 1935 to 1942. (Photograph by Nemo Warr, courtesy of Gesu Parish Archives.)

Sister Mary Richard Cawley, Gesu principal from 1937 to 1943, attended the Gesu golden jubilee anniversary festivities in 1972. (Photograph by Nemo Warr, courtesy of Gesu Parish Archives.)

Among the women who became IHM nuns were the five Sullivan sisters. Seen here, from left to right, are Sullivan siblings Angela, Marie Sylvia, Genevieve, Margaret, and Janet, along with their father Michael Sullivan. Two Sullivan sisters taught at Gesu. Sister Margaret Sullivan, once known as Sister Malachy, taught fifth and sixth grade from 1940 to 1945. She turned 101 in 2017, while living at the IHM Motherhouse in Monroe. Sister Marie Sylvia, who died in 1994, taught at Gesu from 1958 to 1964 and from 1967 to 1971. (Courtesy of SSIHM Archives.)

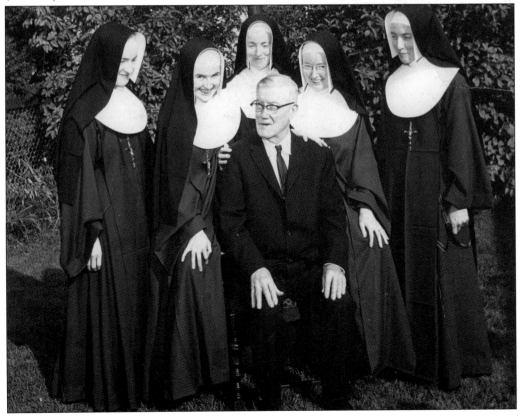

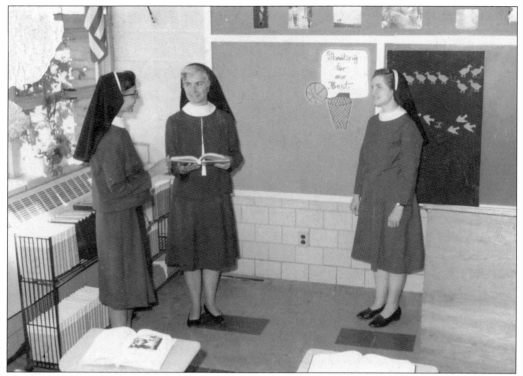

There was not enough room at Gesu School in the late 1960s to accommodate all the students, so children from younger grades were bused to an annex a few miles away, the former school of St. John Vianney Parish in Highland Park. Their teachers, from left to right, were Sisters Mary Faith Hughes, Noreen Therese Tenbusch, and Mary Sylvia Sullivan. (Courtesy of Gesu Parish Archives.)

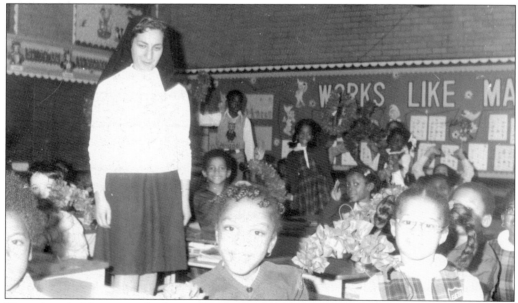

Sister Angela Meram taught first and second graders at Gesu from 1976 to 1980. In 1977, Gesu enrolled 1,030 students. (Courtesy of SSIHM Archives.)

Sister Colleen Sheridan, who taught second grade at Gesu from 1967 to 1970, shares a good time with unidentified friends. (Courtesy of Gesu Parish Archives.)

Morning Mass in the Gesu convent chapel was a ritual. In 1956, Gesu nuns hosted visiting Sisters from Mexico. (Photograph by William D. Moss Studio, courtesy of Gesu Parish Archives.)

Gesu Catholic Schoo

Detroit, Michigan

1925 - 2012

1925-1927 - Principal
Sister Lucilla Toomey 1876-1970

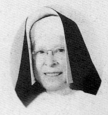

1927-1930 - Principal
Sister Ignatius Brady 1887-1971

1930-1931 - Princip
Sister Marie Lucille Stevens

1937-1943 - Principal
Sister Mary Richard Cawley 1897-1987

1943-1946 - Principal
Sister Marie Agnes Flanigan 1898-1989

1946-1952 - Princip
Sister Joan Therese Lynch

1958-1964 - Principal
ister Marguerite Tourangeau 1899-1995

1964-1967 - Principal
Sister Benice LaPorte 1914-2001

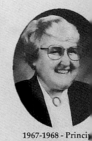

1967-1968 - Princi
Sister Theresa Mil

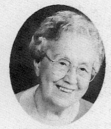

1968-1971 - Principal
Sister Adele DuRoss 1914-2009

1968-1971 - Assistant Principal
Sister Dolora Neumaier

1971-2000 - Princi
Sister Stella Rabaut 1

1931-1937 - Principal
Sister Eudora Baker 1889-1978

1952-1958 - Principal
Sister Ann Joseph Fix 1898-1988

1967-1968 - Principal
Sister Mary Ann Bilgen 1932-1993

1974-1995 - Assistant Principal
Sister Cecilia Campbell

This photograph hangs prominently in the main hallway of Gesu School. It showcases every IHM Sister who was school principal at Gesu. In the 20th-century heyday of Catholic schools, the IHM Sisters were the preeminent teaching congregation in southeastern Michigan. They staffed 97 schools in the state in the mid-1900s. Generations of Detroit-area Catholics were taught by the IHM Sisters, distinguished by their royal blue habits. Sister Stella Rabaut was the last religious principal at Gesu. Since 2001, Gesu principals have been laypeople—Richard Seefelt, John Champion, and, since 2012, Christa Laurin. As the number of Catholic schools and nuns teaching in them has dramatically dwindled, the IHM Sisters have made their mark as progressive activists. There is no longer an IHM Sister teaching at Gesu, but the congregation has supported the school with contributions and a 2015 effort to assemble a digitized Gesu alumni database. (Courtesy of Gesu Parish Archives.)

Sister Adele DuRoss, Gesu's principal from 1968 to 1971, received a bouquet during the 1969 Gesu eighth-grade graduation. (Photograph by Tom Hagerty.)

These three IHM Sisters were in the classroom on the first day of school at Gesu in September 1925. They gathered in 1982 at the IHM Motherhouse in Monroe to share memories. From left to right are Sister Muriel Leszczynski, Sister Rose Ethel Nestor, and Sister Verita Scofield. Sister Rose Ethel Nestor taught at Gesu from 1925 to 1927 and returned from 1971 to 1977. Sister Muriel Leszczynski and Sister Verita Scofield both taught at Gesu in its first year. (Courtesy of SSIHM Archives.)

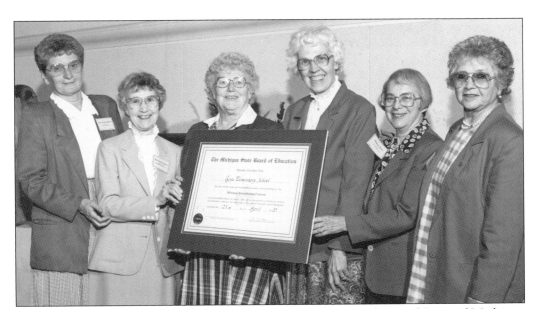

In 1993, Sister Stella Rabaut, third from right, received a certificate of State of Michigan Accreditation for Gesu School. She is pictured here with, from left to right, the Archdiocese of Detroit superintendent of Catholic Schools, Christine Mihelcic; assistant principal Sister Cecilia Campbell, IHM; Sister Patricia O'Donnell, representing the IHM Sisters Steering Committee; and State Board of Education members Kathleen Straus and Annetta Miller. (Courtesy of Gesu Parish Archives.)

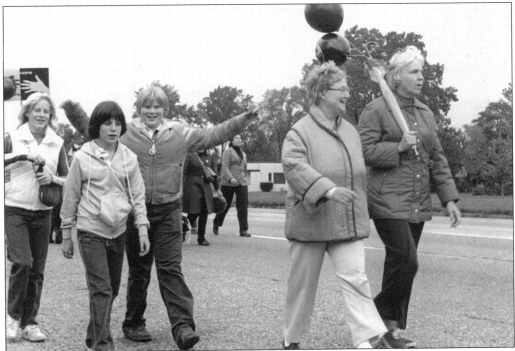

In 1982, Sister Stella Rabaut, right, and Sister Patricia O'Donnell, left, took a hike in the annual walk for Detroit social services agency Focus: HOPE. Gesu School students did the trek with them. (Courtesy of SSIHM Archives.)

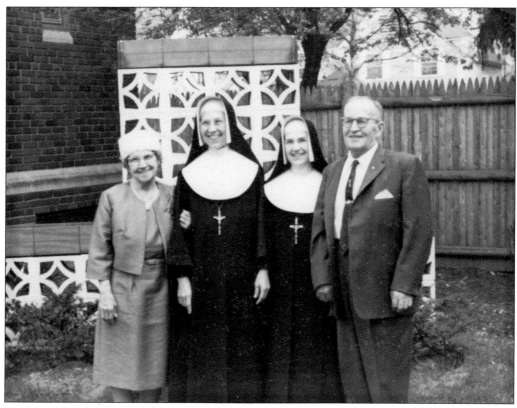

Sister Cecilia Campbell, second from right, was once known as Sister Hermes. She was at Gesu from 1968 to 2002 as a teacher, assistant principal, and office volunteer. Her elder sister, Aurelia, also joined the IHM Sisters, and they are pictured here with their parents. (Courtesy of Sister Cecilia Campbell.)

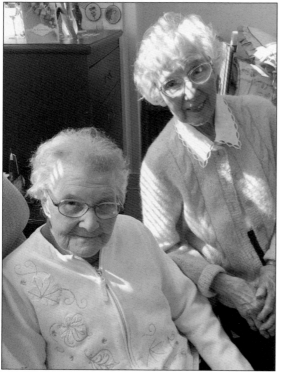

Sister Cecilia Campbell turned 101 in March 2017. She lives at the IHM Motherhouse along with another longtime Gesu staffer, Sister Carola Keffler, right. Sister Carola taught first grade at Gesu in the 1960s. From 1974 to 2005, she was a Gesu School secretary and office assistant. Sister Carola is the last IHM nun to have staffed Gesu School. (Photograph by the author.)

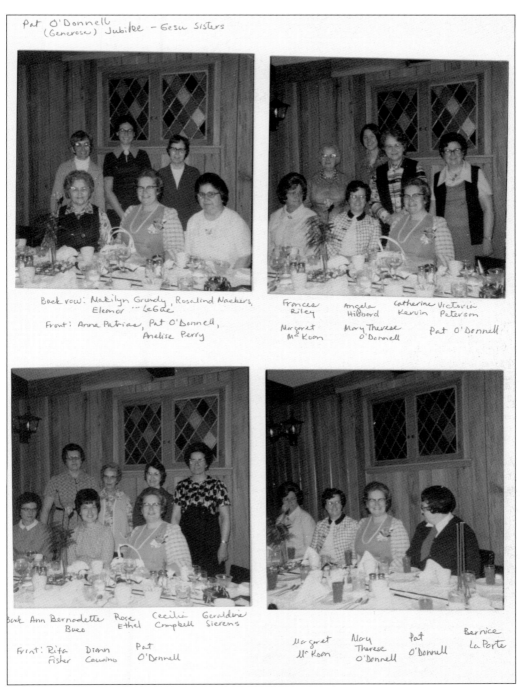

Pat O'Donnell (Generosa) Jubilee — Gesu Sisters

Back row: Marilyn Grundy, Rosalind Naebers, Eleanor LeGae
Front: Anna Patrias, Pat O'Donnell, Anelise Perry

Frances Riley | Angela Hibbard | Catherine Kervin | Victoria Peterson
Margaret McKoon | Mary Therese O'Donnell | Pat O'Donnell

Back: Ann Bernadette Bueo | Rose Ethel | Cecilia Campbell | Geraldine Sierens
Front: Rita Fisher | Diann Cousino | Pat O'Donnell

Margaret McKoon | Mary Therese O'Donnell | Pat O'Donnell | Bernice LaPorte

This is a photo album page from the golden jubilee party celebrating Sister Patricia O'Donnell's 50 years as an IHM Sister. Once known as Sister Generosa, she taught eighth grade at Gesu from 1972 to 2004. She also was the school's financial officer from 2004 to 2006. Many of the partygoers also had taught at Gesu. (Courtesy of SSIHM Archives.)

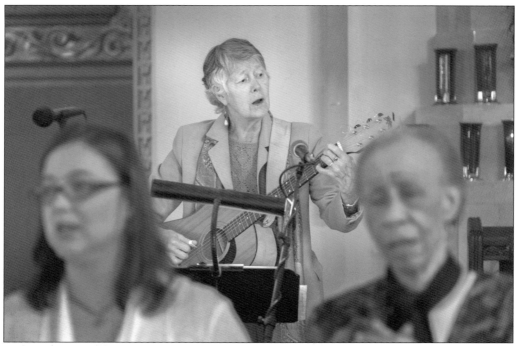

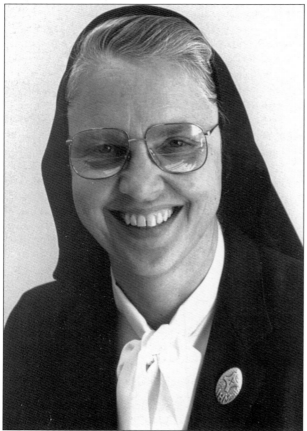

There is one member of the IHM congregation who still works at Gesu. Sister Angela Hibbard continues the record of IHM Sisters serving Gesu parishioners. She is Gesu's pastoral associate and has been affiliated with the parish since 1974. She has been a harmony-making member of the Gesu choir since then, and her guitar playing is a staple not only at Sunday Masses, but also at parish gatherings. (Photograph by Diane Weiss.)

Inspired by the nuns who taught them, two dozen Gesu parish and school alumnae joined the IHM congregation over the years. Among them was Gesu School alum Sister Amata Miller. An economist, she was chief financial officer for the IHM congregation and Marygrove College. She was president of the national Catholic social justice lobby, Network, between 1985 and 1986. (Courtesy of SSIHM Archives.)

Seven

JESUITS AT THE HELM

Jesuit priests have been making history in Michigan since the late 1600s. In Detroit, they shaped history for tens of thousands of Catholics by establishing Gesu Parish. The Reverend Norman Dickson is one of 16 Jesuits who have been Gesu pastors from 1922 to 2017. (Photograph by Michael Sarnacki.)

John McNichols, S.J.
Founder

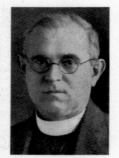

Justin F. De La Grange, S.J.
Pastor 1924-1926

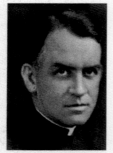

Joseph T. Lannon, S.J.
Pastor 1931-1938

Thomas J. Moore, S.J.
Pastor 1938-1948

Joseph A. Muenzer, S.J.
Pastor 1969-1976

John C. Kehres, S.J.
Pastor 1976-1980

James F. Lotze, S.J.
Pastor 1993-1997

Norman J. Dickson, S.J.
Pastor 1997-2005

Over the next two pages are photographs of the 16 Jesuit priests who have led Detroit Gesu from 1922 to 2017. Priests from the Society of Jesus, the order's formal name, explored the Great Lakes more than 300 years ago. A French Jesuit missionary, Father Jacques Marquette, established a settlement in Sault Ste. Marie in Michigan's Upper Peninsula in 1668. He founded St. Ignace in the Upper Peninsula in 1671. The Michigan city of Marquette is named after him, as is the Pere Marquette River. In Detroit, McNichols Road, also known as Six Mile Road, was named after the founding pastor of Gesu, Fr. John McNichols, who also was the president of the University of Detroit. (Courtesy of Gesu Parish Archives.)

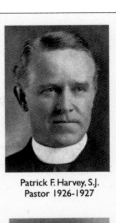
Patrick F. Harvey, S.J.
Pastor 1926-1927

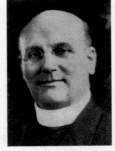
David E. Hamilton, S.J.
Pastor 1928-1931

Edward C. Holton, S.J.
Pastor 1948-1963

John C. Schwarz, S.J.
Pastor 1963-1969

Gesu's first resident pastor was Fr. Justin F. De La Grange, "who endeared himself to the entire Parish through his able character and constant sacrifices on behalf of the young Parish," notes a newspaper clipping of the day. Gesu Catholic Church was built under the leadership of Fr. Joseph Lannon, a Chicago native. "The indefatigable zeal of the Gesu pastors has been outstanding and has been no small factor in the steady growth of the Parish," reads a newspaper clipping from the church's dedication in 1937. "Working together in closest harmony and co-operation, the pastor and parishioners have always kept uppermost the high purpose of creating in the Gesu Parish a stronghold where Christ's teachings lived in the hearts of his children and became the greatest monument to the Man of Galilee." (Courtesy of Gesu Parish Archives.)

James K. Serrick, S.J.
Pastor 1980-1987

Dennis T. Dillon, S.J.
Pastor 1987-1993

David E. Watson, S.J.
Pastor 2005-2009

Robert J. Scullen, S.J.
Pastor 2009-Present

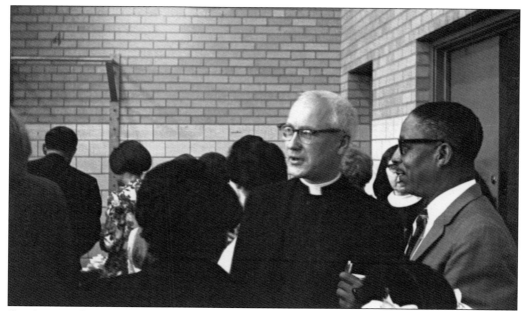

Gesu's pastor from 1963 to 1969, the Reverend John Schwarz sought to stress Catholic teaching to bridge racial tensions roiling through his parish and the city. In 1965, Schwarz told parishioners that integration in Detroit's neighborhoods was one of the "designs of God" and that Catholics should "not only look toward God but toward each other" to battle prejudice. He later left the priesthood. (Photograph by Tom Hagerty.)

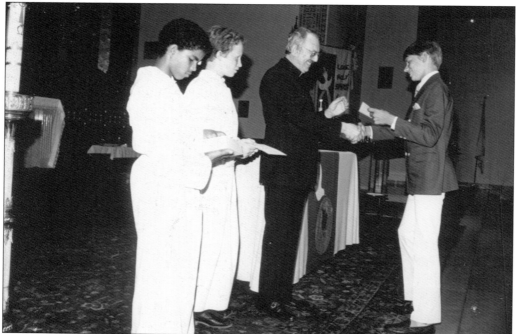

The Reverend James Serrick is credited for promoting the initiative Christ Renews His Parish, which spurred the building of relationships between black and white parishioners through retreats and discussions. He also had a sideline rebuilding and renovating organs. (Courtesy of Gesu Parish Archives.)

Father Serrick was photographed taking notes at Detroit's Sacred Heart Seminary during a "Peace Pastoral" presentation in 1985. When he left Gesu in 1987, students Stephanie Gentry and Michelle Gaskill wrote in the *Gesu Journal* that "on Father Serrick's last Sunday at Gesu, he said that we served him. But he really is the one that served us and helped in making Gesu the place that it is." (Courtesy of *Michigan Catholic*.)

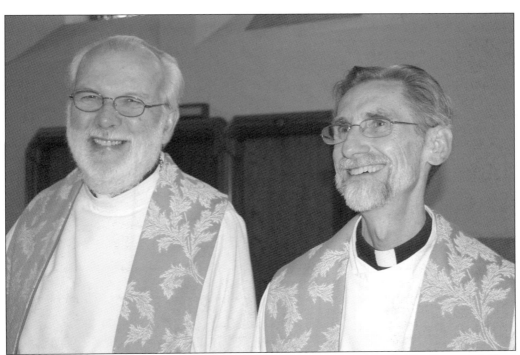

The Reverend Dennis Dillon, left, was Gesu pastor from 1987 to 1993. The Reverend Gary Wright, right, had been a Gesu associate pastor. For Gesu's 1987 renovation, Dillon wrote: "We build this House of God for the future as well, for those who continue to live and worship here . . . So, with joy, we rededicate ourselves to each other, to the City of God in the City of Detroit." (Photograph by Patricia Harrington.)

The Reverend John Kehres was pastor from 1976 to 1980. *Detroit Free Press* columnist Louis Cook wrote in 1977 that Gesu School had "1,030 students—racially fifty-fifty. The parishioners are, possibly, 25 percent black. Fr. Kehres is not certain—because it makes no difference to him. The parish bulletin usually contains the statement "We, the people of Gesu, are one in the body of Christ." (Courtesy of Gesu Parish Archives.)

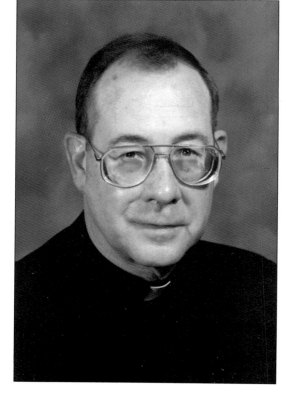

The Reverend James Lotze, SJ, was pastor of Gesu from August 1, 1993, until his death on August 15, 1997. Parishioner Allen Jones II urged parishioners via the *Gesu News* to honor Lotze by adding "5 minutes to your prayer time" and keeping commitments. He said that Lotze "made a habit of saying to me 'make a list' and 'let's just get this one thing accomplished.' " (Courtesy of Gesu Parish Archives.)

Eight

GESU LUMINARIES

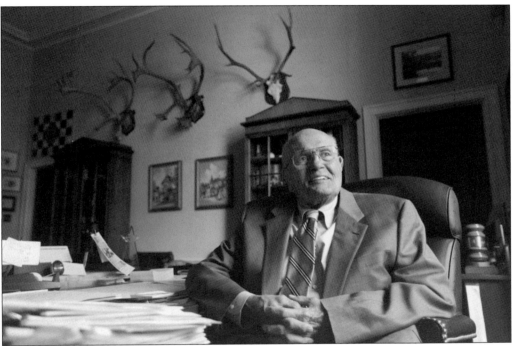

US representative John D. Dingell served in Congress from December 13, 1955, to January 3, 2015, and his tenure was the longest in congressional history. A powerful voice for Democratic Party ideals, Dingell succeeded his late father, John D. Dingell Sr., who served in Congress from 1933 to 1955. Dingell has said both he and his father were at the first Mass celebrated in 1936 at the new Gesu church. As a Gesu School student, Dingell said Sister Marie Lawrence was a "saint" for her influence on him. Among legislation he worked on and fought to pass were landmark initiatives, such as the Civil Rights Act, Medicare legislation, the Clean Water Act, the Endangered Species Act, and the Affordable Care Act in 2010. His wife, Debbie Dingell, has succeeded him. (Courtesy of *Detroit Free Press*.)

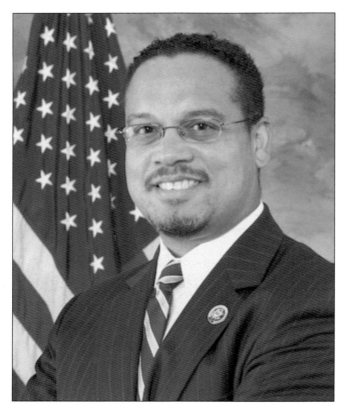

Keith Ellison is a US congressman from Minnesota who grew up in Gesu Parish. His parents, Clida and Leonard, are longtime Gesu parishioners. A lawyer, Ellison converted to the Muslim faith. He is the first Muslim to be elected to Congress and the first African American US representative from Minnesota. In 2017, he also became vice-chair of the Democratic National Committee. (Courtesy of Rep. Keith Ellison.)

The Fisher brothers—who along with their uncle established the Fisher Body auto firm and constructed Detroit's iconic Fisher Building—were parishioners and benefactors of Gesu Parish. Many of their children attended Gesu School. Pictured here at an October 1947 dedication of a Fisher Building plaque honoring the eldest Fisher brother, Fred J. Fisher, are, from left to right, Charles T. Fisher, Charles T. Fisher Jr., Burtha Fisher, William P. Fisher, Lawrence P. Fisher, Edward F. Fisher, and Alfred J. Fisher. (Courtesy of Walter P. Reuther Library, Wayne State University.)

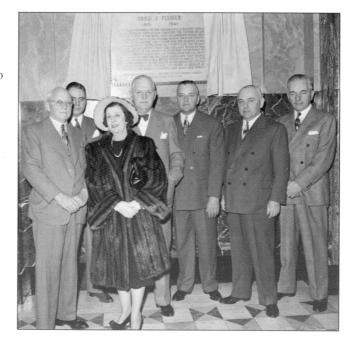

Detroit mayor Eugene Van Antwerp, center, was a Gesu parishioner, and his children attended Gesu School. Van Antwerp was first elected to the Detroit Common Council in 1931. He served as mayor in 1948–1949 and returned to the council in 1951. When he died in August 1962, van Antwerp was considered the council's dean. (Courtesy of Walter P. Reuther Library, Wayne State University.)

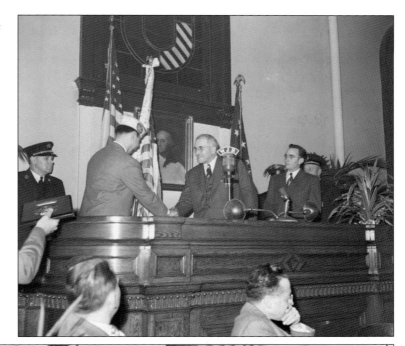

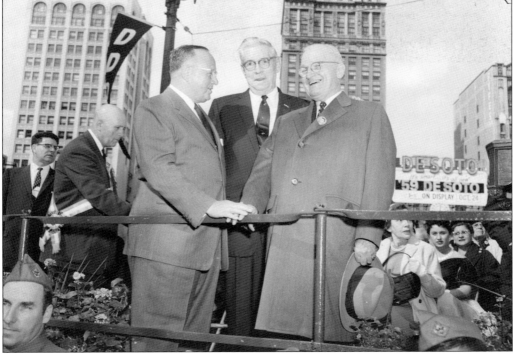

Louis Miriani, left, was Detroit mayor from 1957 to 1962 and welcomed former president Harry Truman to Detroit for a Columbus Day celebration in 1958. In the center is then US senator Patrick McNamara. Miriani, a Gesu parishioner, also was a city council president and the last member of the Republican Party to lead Detroit. Detroit's Cobo Hall complex was built under his tenure. In 1968, Miriani was convicted for failing to report $261,000 in income and received a one-year sentence. (Courtesy of Walter P. Reuther Library, Wayne State University.)

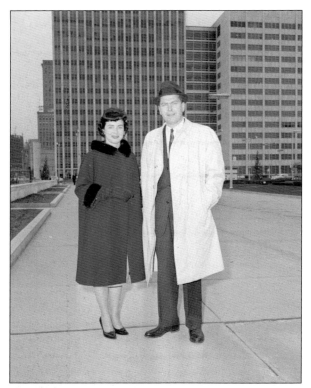

Jerome P. Cavanagh was a dynamic, liberal Democrat touted for a bright political future after he became Detroit mayor, and served from 1962 to 1970. But his tenure was defined by the 1967 Detroit riot, an uprising spurred by police brutality against African Americans as well as unemployment and housing discrimination. At left, Cavanagh is pictured with first wife, Mary Ellen, at Detroit's City-County Building, now known as the Coleman A. Young Municipal Center. Cavanagh's eight children attended Gesu. The photograph below was taken in the family home on Parkside Street. From left to right are (first row) Mary Ellen holding Angela, Phil, Therese, and Jerome holding Jerome Celestin; (second row) Christopher; (third row) David, Mark, and Patrick. (Left, courtesy of Walter P. Reuther Library, Wayne State University; below, courtesy of Mark Cavanagh.)

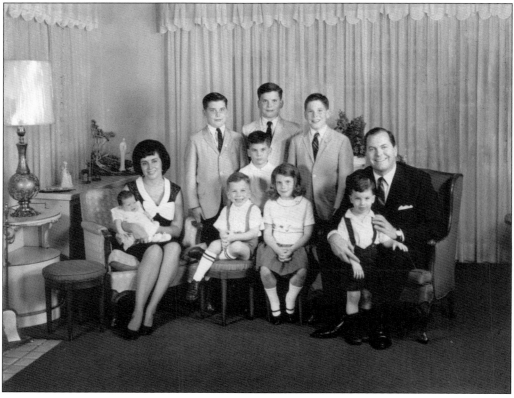

Detroit mayor Dennis Archer, who served from 1994 to 2001, is a Gesu parishioner, along with his wife, retired Wayne County 36th District judge Trudy DunCombe Archer. Before he was sworn in as mayor in January 1994, Archer attended a prayer service at Gesu. As he kneeled at the altar, his two sons, Dennis Jr. and Vincent, stood behind him. Archer is a former Michigan Supreme Court justice and the first African American president of the American Bar Association. (Both, courtesy of Dennis Archer.)

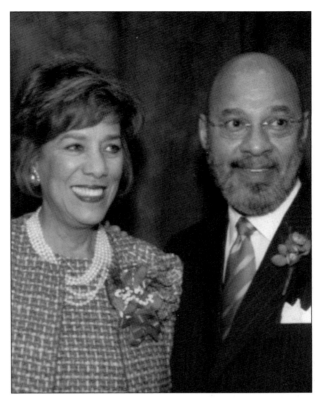

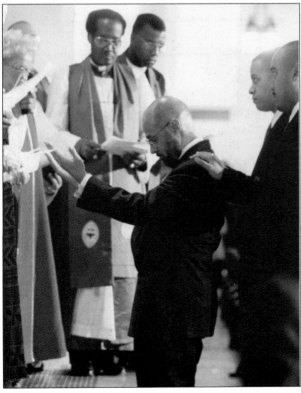

Detroit Tigers slugger Charlie Gehringer, left, attended Gesu Church. Here, he is pictured with Hall of Famer Hank Greenberg. On the day Gehringer was inducted into the National Baseball Hall of Fame in 1949, he drove to California to marry Josephine Stillen, a secretary and Gesu parishioner. He did not want to be part of the Hall of Fame hoopla. (Courtesy of *Detroit Free Press*.)

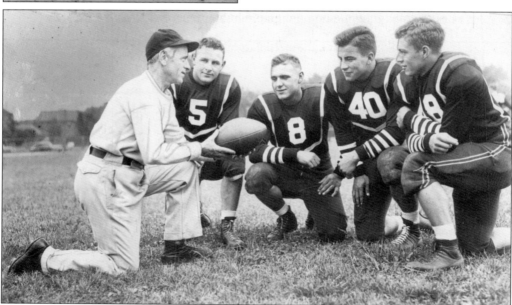

Gus Dorais was a football All-American and a Notre Dame teammate of Knute Rockne. He and Rockne are credited with promoting football's forward pass. Parishioner Dorais coached the University of Detroit football team from 1925 to 1942 and was the Detroit Lions coach from 1943 to 1947. A Gesu service award was named after Dorais's son David, who drowned in 1947. (Courtesy of University of Detroit Mercy Archive and Special Collections.)

James Brickley was a Gesu parishioner and Detroit City Council member before he was tapped to be lieutenant governor under Michigan governor William Milliken. Brickley also was president of Eastern Michigan University and a Michigan Supreme Court justice. (Courtesy of *Detroit Free Press*.)

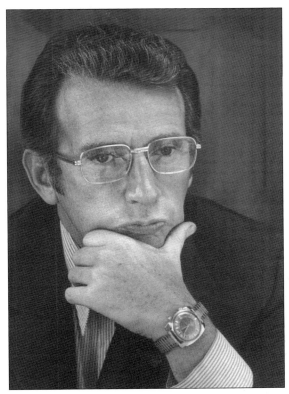

Percy Gabriel was a renowned jazz musician who with family members formed the Gabriel Brothers New Orleans Jazz Band. When Percy died at age 77 in 1993, his funeral from Gesu included a traditional New Orleans jazz band procession. He is pictured here with his wife, Esther, at their 50th anniversary along with their children. (Courtesy of James Anderson.)

Martha Lavey, Gesu '71, was the artistic director of Chicago's famed Steppenwolf Theatre from 1995 to 2015. Her vision made Steppenwolf "a showcase for acclaimed productions and an incubator for new plays and young playwrights," reads her *New York Times* obituary following her death on April 25, 2017. (Photograph by Joel Moorman, courtesy of Steppenwolf Theatre.)

Grace Morand, Gesu '71, has contributed harmonies to the Chenille Sisters since 1985. She is flanked by Connie Huber, left, and Cheryl Dawdy, right. The trio has performed across the country and often sang on Garrison Keillor's radio show, *Prairie Home Companion*, on NPR. (Courtesy of the Chenille Sisters.)

Aaliyah, the late R&B singer, attended Gesu School from kindergarten through sixth grade as Aaliyah Haughton. Her song "Journey to the Past" from the film *Anastasia* was nominated for an Oscar in 1998. Her albums were *Age Ain't Nothing But a Number*, *One in a Million*, and the self-titled *Aaliyah*. She died at age 22 in a plane crash on August 25, 2001, and a crowd gathered at the Detroit School of Arts High School for a memorial. (Photograph by John Greilick, courtesy of *Detroit News*.)

Airea Mathews, a longtime Gesu parishioner now teaching creative writing at Bryn Mawr College, is an award-winning poet. Her first collection of poems, *Simulacra*, received the 2016 Yale Series of Younger Poets Award (Yale University Press, 2017). She also received the 2016 Rona Jaffe Foundation Writers' Award. (Courtesy of Airea Mathews.)

Long before he portrayed President Obama's comically inspired "Anger Translator," actor Keegan-Michael Key was a Cub Scout and student at Gesu School. The comedy sketch show, *Key and Peele*, which paired Key with actor Jordan Peele, delighted audiences on the Comedy Central network from 2012 to 2015. The show won two Emmy Awards and a Peabody Award. Key and Peele developed the Luther character to satirize what the diplomatic Obama might really be thinking about his critics. Key brought Luther to the 2015 White House Correspondents' Association Dinner and stood alongside the real Obama, firing off zingers. Keegan-Michael and his brother Kristoffer Key both graduated from Gesu. (Left, courtesy of Trish Walsh; below, photograph by Barry King.)

Nine

PARISH LIFE

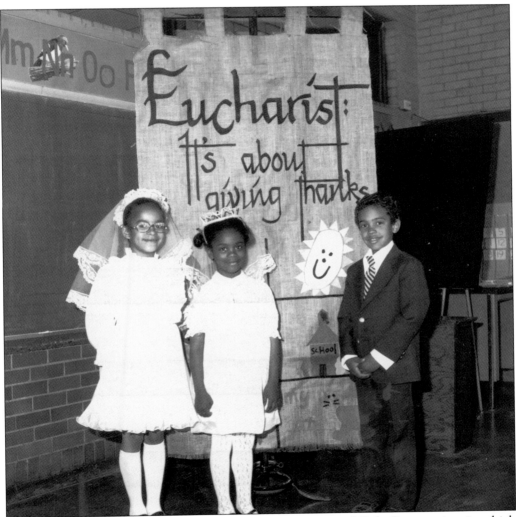

At the center of the Roman Catholic faith is the sacrament of Holy Communion, in which Catholics believe the Eucharist is the body of Christ. These Gesu second graders made their First Communion in 1982. Gesu has always teemed with activity to strengthen the faith and renew the spirit. Through the decades, Gesu's impact has been revealed through everyday and landmark occasions in parishioners' lives. (Courtesy of Gesu Parish Archives.)

To legions of Gesu altar boys, Edmund "Eddie" LaHaie was the man with the gray goatee in the black cassock behind the door to the sacristy of Gesu Catholic Church. "It was his solemn duty to protect the holy oils and sacred relics, the priest's vestments, the chalices and the boxes of unblessed wine in the basement," recalled Fred Diehl, Gesu '76. "Eddie taught altar boys that 'yes,' it is possible to strike one match and light candles on both ends of the 8-foot-long altar; and 'no,' you don't ring the bells during the consecration as if you were an ice-cream truck announcing your presence. Eddie put a couple of crumpled dollar bills in your pocket if you worked all the Masses during Holy Week. He and his wife, Emma, lived on Quincy Street right across from the Church so it was not uncommon for a batch of homemade sandwiches to arrive unannounced." He was Gesu's sacristan for 17 years before his death at age 83 in 1981. (Courtesy of Gesu Parish Archives.)

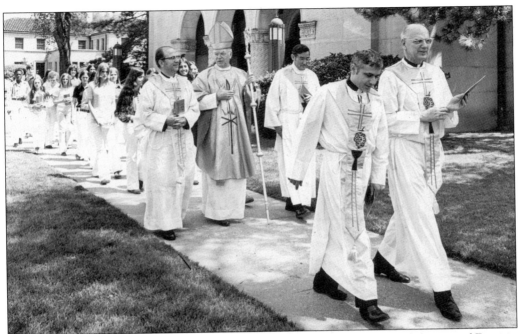

Gesu celebrated its 50th anniversary in 1972 with a Mass led by the Archdiocese of Detroit, Cardinal John Dearden. Gesu School students are part of the procession, and to the right of Dearden is its then pastor, Fr. Joseph Muenzer. In the school gym, a celebration brought hundreds of parishioners together. Gesu teacher Gerre Wood Bowers—in the photograph below with her back to audience—led students in a musical tribute called *Through the Years*. The school's 1,250 students were involved in the show, billed as a musical trip from 1776 to the Age of Aquarius. There were baton twirlers and students who portrayed 1920s silent-movie actors and Ziegfeld Girl dancers. The first graders sang "Git Along, Little Dogies" and the "Streets of Laredo," according to the program kept by Gesu student Mike McElhone. The Junior High Chorale sang "Let the Sunshine In." A two-record set of the recordings was available in the parish office. (Both, photograph by Nemo Warr, courtesy of Gesu Parish Archives.)

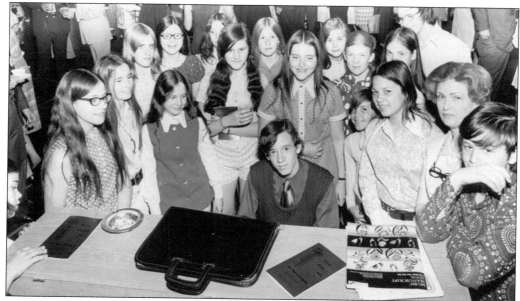

In 1972, students gathered around the piano at the Gesu Golden Jubilee, which also included an audience sing-along to "Shine on, Harvest Moon." Church members also raised their voices with Gerre Bowers, below at the piano. "Reaching the half-century mark is a time for both reflecting on past achievements, and settings for future challenges and opportunities," reads the preface to the musical program. (Both, photograph by Nemo Warr, courtesy of Gesu Parish Archives.)

There were toasts for Gesu at the parish's Golden Jubilee in 1972. "Today, the 1600 Gesu parish families support an elementary and junior high school totaling 1200 children. The vitality of Gesu is reflective of the work of many different organizations, old and new, always working with one particular goal in the back of their minds—to make Gesu community a fine place to live and worship," read the program. Gesu remained one of Detroit's largest Catholic schools, but had 400 fewer students in 1972 from its peak a few years earlier. Part of that reflected the waning of the baby boomer generation passing through classrooms everywhere, and it also was due to the accelerated exodus of white Catholics after the 1967 Detroit riot. (Photograph by Nemo Warr, courtesy of Gesu Parish Archives.)

Gesu has long been a center of spiritual renewal and community action. In July 1981, in a Mass for the people of Nicaragua, Bernard Grunow places flowers at the altar while his father, Ken, looks on. Today, Gesu activists organize for a myriad of causes, including going door-to-door to find and help people at risk of losing homes to foreclosure. (Courtesy of *Michigan Catholic*.)

These Gesu parishioners were pioneers in parish race relations. They travelled to a retreat in Cleveland to learn how to facilitate frank discussions about race through the Christ Renews His Parish program. Other retreats followed as Rev. James Serrick recruited black and white parishioners to attend together. Longtime parishioners say that was a turning point in unifying the congregation. (Courtesy of SSIHM Archives.)

In 1987, Gesu undertook a major renovation with architect Gerald G. Diehl at the helm; he was the son of the church's original architect. It was a massive effort designed to bring the altar into the midst of worshippers. The church's main altar, once aligned with the south wall, was brought forward to allow the oak pews to radiate around it. (Courtesy of Gesu Parish Archives.)

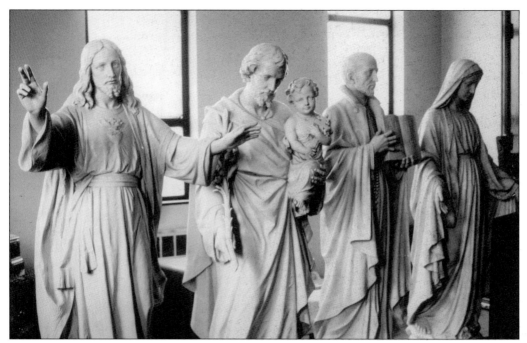

The statues from the church's side altars were grouped together as they awaited the completion of the 1987 renovation. From left to right, the statues represent the Sacred Heart of Jesus, St. Joseph holding the baby Jesus, Jesuit order founder St. Ignatius Loyola, and Mary, the Blessed Mother. (Courtesy of Gesu Parish Archives.)

One goal of the Gesu renovation was to reflect a smaller congregation. The church was built for 1,500. The renovation changed the church seating, recutting the old pews to angle around the altar for about 600. The Stations of the Cross were aligned against a half wall on the church's east side, which carved out space for the social area, where coffee and donuts are served after Sunday Masses. (Courtesy of Gesu Parish Archives.)

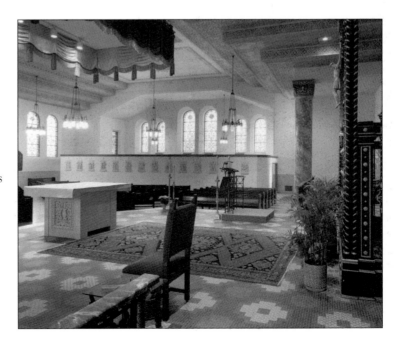

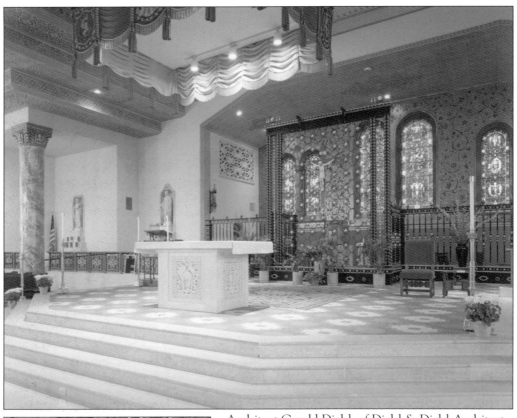

Architect Gerald Diehl, of Diehl & Diehl Architects, said his father built the original Gesu—including the pews, stained glass, and organ—for about $225,000. He told the *Michigan Contractor and Builder* magazine that the renovation cost more than $300,000. Ornamental ironwork and marble from the reconfigured altar was used in other parts of the renovation and has been used since in other updates. (Courtesy of Gesu Parish Archives.)

In 1974, the Gesu Leisure Group was formed under the leadership of Jo Diehl and Mary Ellen McCormick, pictured center and right. Its first meeting drew 21 participants and through the years grew to some 200 members, drawing from the neighborhood and other parishes. They explored the city and state by bus, as in this trip to Indian River, Michigan. One of the group's signature events was the Strawberry Shortcake Festival. (Courtesy of Gesu Parish Archives.)

The Gesu Phase II Group, cofounded by parishioner Rose Mary Lucas, initially started as a support group in 1979 for the newly widowed. It has adapted and welcomes women coping with life's changes. (Courtesy of Rose Mary Lucas.)

The sacrament of Confirmation is an annual event at Gesu Catholic Church. In this photograph from the early 1990s, new Detroit archbishop Adam Maida confirms a young man. Pope John Paul II bestowed a cardinal's red hat on Maida in 1994, and Maida retired as the archbishop in 2009. (Courtesy of Gesu Parish Archives.)

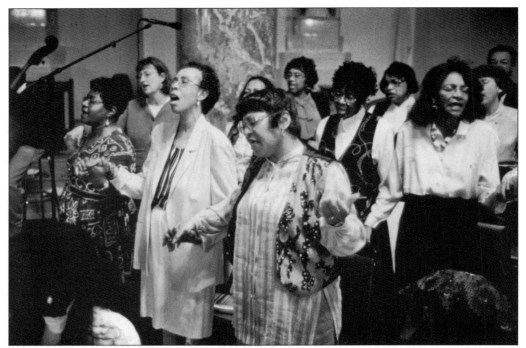

Members of the Gesu choir, led by Gesu's music director Carl Clendenning, sing at the parish's Easter Vigil on April 3, 1999. Clendenning, an instrumentalist and vocalist accomplished in both classical and African American music, joined Gesu's staff in 1984. (Photograph by Michael Sarnacki.)

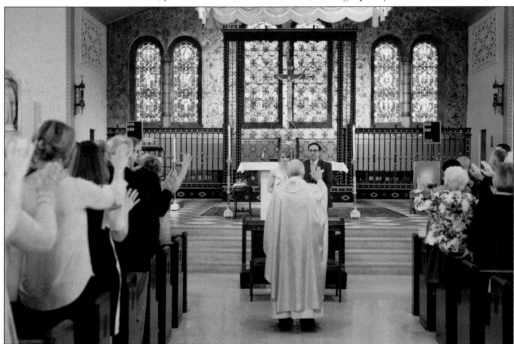

Music is in the air at Gesu weddings. At their October 2016 wedding, Michelle Leppek and Scott Wozniak bowed their heads to receive a blessing from Gesu's pastor, the Reverend Robert Scullin, and guests extended outstretched hands to do the same. (Photograph by Mae Stiers.)

Florence Mary White, a Gesu alum, married John Rittersdorf on January 6, 1944, at Gesu. She lived on Quincy Street and attended Gesu School the one and only year it had a ninth grade. The couple had four daughters—Elaine, Marcia, Mary Kay, and Linda—who were all baptized at Gesu Catholic Church, graduated from Gesu School, and married at Gesu. (Courtesy of Linda Rittersdorf Keimig.)

Edward Stone walks his sister Adele down the aisle on December 20, 1952. She married William Henry Drumond. The brother and sister had both attended Gesu. (Courtesy of William Drummond Jr.)

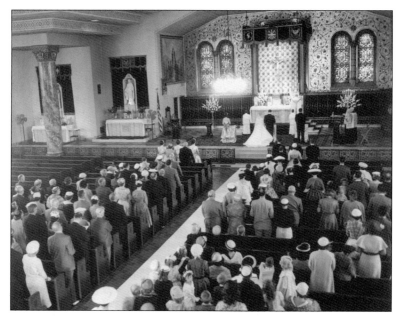

Isabel Francis graduated from Gesu in 1949, became a teacher, and married Louis Smith in June 1958. Her first graders from a Ferndale public school attended her wedding, although they strained from back pews to get a view. (Courtesy of Isabel Smith.)

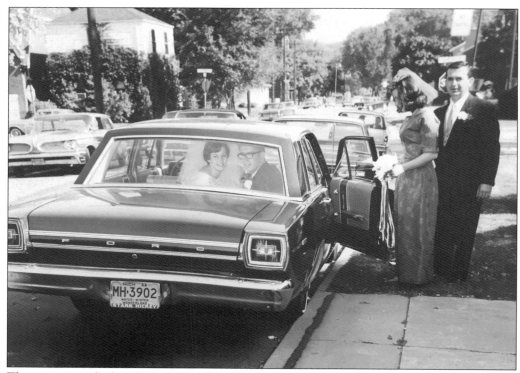

This car was parked on Santa Maria Street to whisk away newlyweds Kathleen Crane and Dan Fedorko after their wedding ceremony at Gesu in October 1966. Also pictured are the best man, John Fedorko, and the maid of honor, Jean Crane. (Courtesy of Molly Crane.)

The carved columns of Gesu frame the newly married Lois Gabriel and James Anderson at their wedding in 1996. The couple lives in Georgia, where James is a deacon assigned to SS. Peter and Paul Catholic Church in Decatur in the Archdiocese of Atlanta. (Courtesy of James Anderson.)

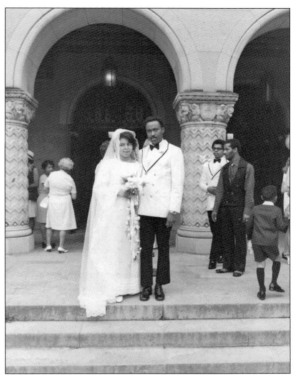

When Susan Brennan married Christopher Tarnas in December 1988, it was the union of two Gesu alums. Susan's father, Michael J. Brennan, also had graduated from Gesu; her mother, Rachel Rahaim Brennan, remains an active parish volunteer. Pictured are, from left to right, Rick Brennan, the bride's brother who attended Gesu; Rachel Brennan; Michael Brennan; Susan and Christopher Tarnas; and the bride's other siblings, Michael, Kathleen, and Thomas, who all graduated from Gesu as well. (Courtesy of Rachel Brennan.)

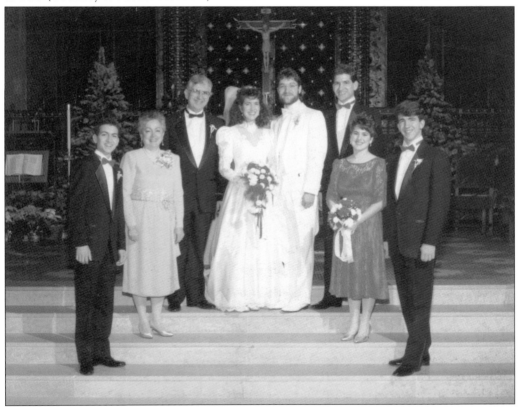

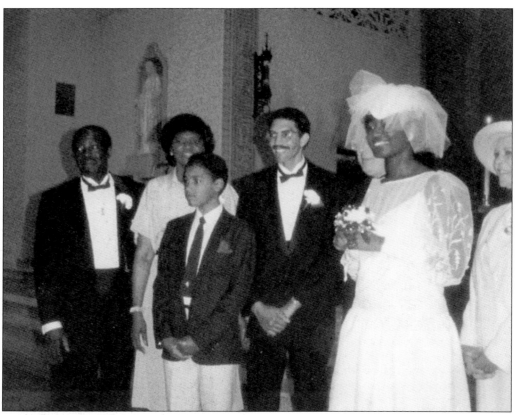

Marcia Lynn Cooke married Marc Shelton in June 1985. Both their families have been longtime Gesu parishioners and remained friends even after the couple divorced. Marc died in 2007. Marcia is a US district judge in Miami. Her sister is parishioner DeLois Cooke Spryzak, a Gesu alumna and the mother of two Gesu alums. Pictured from left to right are Marcia's parents, Heyward and Ella; her then brother-in-law, Matthew Shelton; Marc and Marcia; and then mother-in-law Elizabeth Shelton. (Courtesy of Marcia Lynn Cooke.)

Patricia Simmons married Byron Bouey in December 1986. Here, they are posing with Deacon Ron McIntyre. (Courtesy of Patricia Simmons Bouey.)

An altar boy brings light to the darkness, starting the Easter Vigil at Gesu on April 3, 1999. Photographer Michael Sarnacki has long photographed the service of Detroit-area Jesuits and originally took these photographs for the Jesuit magazine *Company*. (Photograph by Michael Sarnacki.)

Gesu's pastor, Fr. Norman Dickson, SJ, and Deacon Ron McIntyre washed the feet of parishioners on Holy Thursday in 1999. The Holy Week foot-washing ritual re-creates Jesus's care of his apostles at the Last Supper. (Photograph by Michael Sarnacki.)

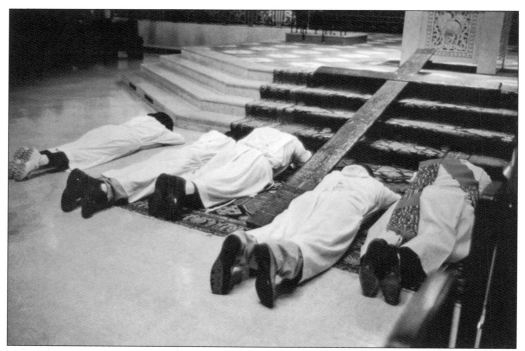

The celebrants prostrate themselves at the foot of the altar at Gesu Catholic Church on Good Friday, April 2, 1999. It is an act of submission to a greater power and also signifies the grief of the faithful at Jesus's crucifixion. (Photograph by Michael Sarnacki.)

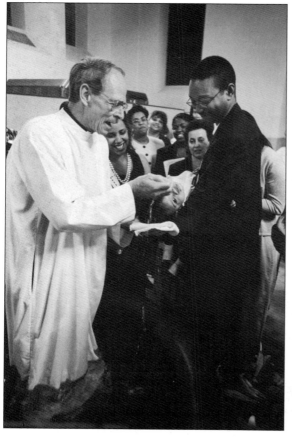

It was all smiles as Fr. Norman Dickson conducted a baptism at Gesu in 1999 "in the name of the Father, and of the Son, and of the Holy Spirit." (Photograph by Michael Sarnacki.)

Ten

GESU RESURGENT

Gesu Parish is five years away from recording a century of service. In 2012, the church was festooned with banners heralding its 90th anniversary. (Photograph by Patricia Harrington.)

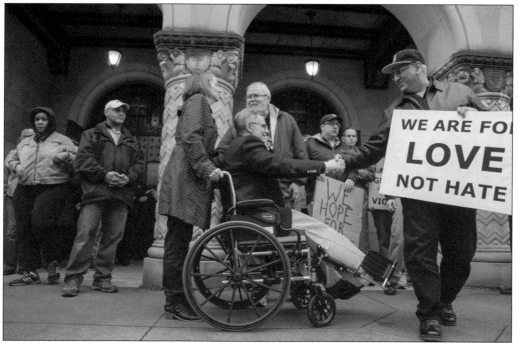

In March 2015, US district judge Terrence Berg was shot fending off a robbery attempt on his front porch, just several blocks from Gesu. The shooting of a federal judge received national media attention. Berg and his wife, Gesu School's community outreach coordinator Anita Sevier, put out a strong message. "We just want people to know that this is not a reason to hate Detroit," Sevier told the *Detroit Free Press*. "Instead of being angry, be part of the solution for the hopeless teens and children of Detroit." The parish organized a Walk for Hope from Gesu just weeks after on Good Friday. Several hundred people participated in the march along Livernois Avenue, as Berg, his shattered leg encased in a bone-setting metal cylinder, was pushed in a wheelchair. In 2016, the judge, healed from his wounds, walked in the second Walk for Hope. (Above, photograph by Ryan Garza, courtesy of *Detroit Free Press*; below, photograph by Steve Perez, courtesy of *Detroit News*.)

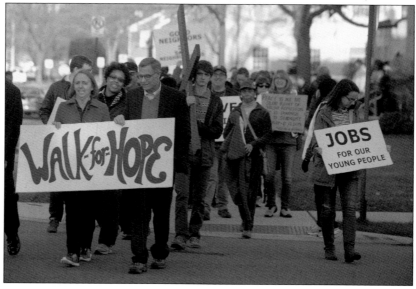

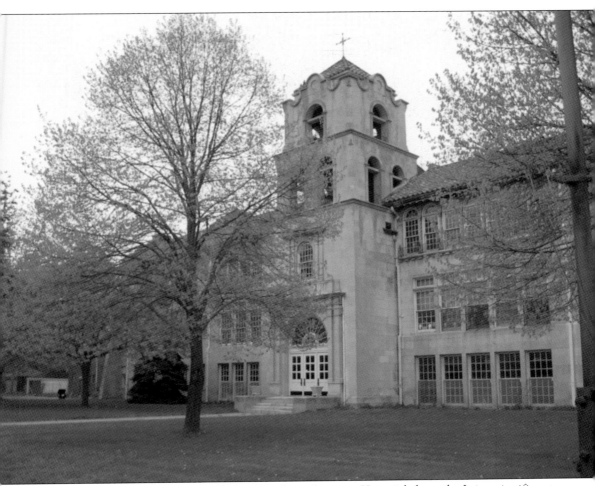

In 2016–2017, Gesu School enrolled 240 students from pre-K to eighth grade. It is a significant bounce from 2012, when enrollment was below 200. Gesu is one of only four Catholic elementary schools remaining in Detroit. Some 50 years ago, there were 108 grade schools. In 2017, Gesu School underwent a renovation in the cafeteria area to remove added walls that blocked natural sunlight from filtering in through its distinctive windows. More young families are moving into neighborhood, and Gesu hopes to see a continued boost in enrollment. (Photograph by Patricia Harrington.)

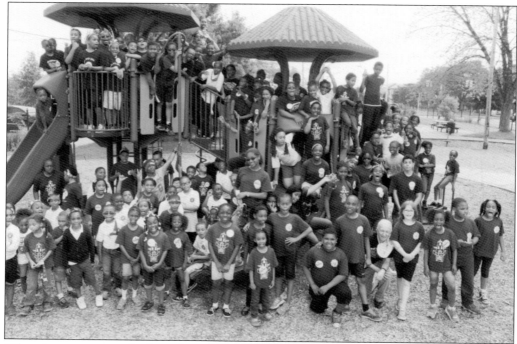

When there was not a safe, clean playground for kids near Gesu, volunteers built one in 2001. The old Gesu Scout House came down and a picnic area, labyrinth, gardens, and play structure were put in its place. The Gesu Community Green was enlarged and upgraded through a Skillman Foundation grant in 2002. Later, a donation from University District resident Jim Edwards added additional play structures and other features. It is an asset for all. (Photograph by Anita Sevier.)

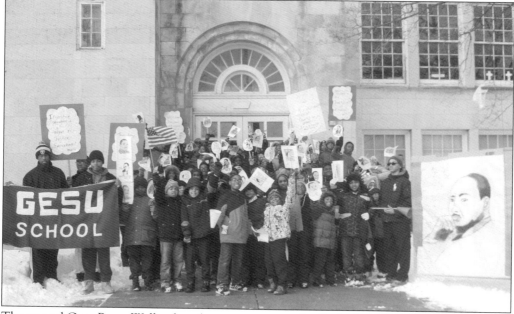

The annual Gesu Peace Walk takes place every year on the Friday before Martin Luther King Jr. Day. The students make signs and walk along Livernois Avenue and through the University of Detroit Mercy campus. (Photograph by Judy Kuzniar.)

Gesu students get excited about their work and are always ready for a close-up. Many photographs capturing student events and accomplishments line the walls of Gesu School. The photographer often was eighth-grade teacher Judy Kuzniar, also a Gesu alumna. From 2004 to 2017, she taught at the school that shaped her childhood and those of her six siblings. (Photograph by Judy Kuzniar.)

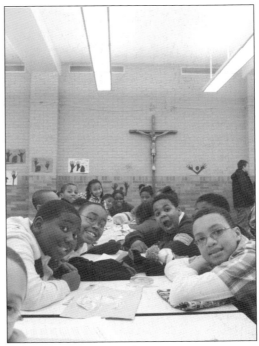

When Gesu students attended an annual Mass for National Catholic Schools Week at Detroit's Cathedral of the Most Blessed Sacrament in 2014, they posed with Detroit archbishop Allen Vigneron. (Photograph by Judy Kuzniar.)

Musical theater returned to Gesu School in spring 2016 after a multiyear absence. Cierra Leggs (right), Gesu '17, played the title role of Annie. Also pictured are Seth Kirk (left) and Frederick Stanley. (Photograph by Patty Doyle.)

This photograph ran on the cover of the 2015 Catholic Schools Week edition of the *Michigan Catholic*, the newspaper of the Archdiocese of Detroit. The story inside describes how the Gesu library underwent a three-year renovation and updated its technology, catalog, and book selection with help from the community. (Courtesy of *Michigan Catholic*.)

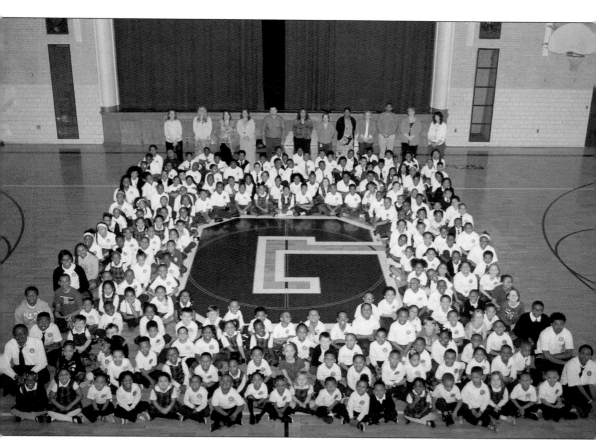

Surrounding the Gesu Giants "G" in the gymnasium, the Gesu student body, teachers, and staff gathered for a school picture in April 2017. Gesu's principal since 2012 is Christa Laurin, who was a lawyer before she worked as a Catholic school teacher and joined Gesu as assistant principal in 2006. The school's 2016–2017 staff included Keith Farrugia, the dean of students; and teachers Bridget Schick, Patty Doyle, Michelle Guibord, Maya Veit, Amanda Coleman, Stephanie Walker, Mary Hall, Justin Cuellar, Judy Kuzniar, and Julia Carlsen. Other teachers included Gary Ashton, Nicole Roser, Mike Mclean, Julie Carpenter, Kristen Grant, Dana Redding, and Alain Pivetta. The Gesu Preschool was directed by Fawn Day, with aides Katerie Criswell, Tayba Morton, Mary Ellis, and Clara Orr. Other members of the Gesu School team included Barbara Brown, Erice Rainer, Bob Lenning, Norma Mason, Carl Threat Jr., Anita Sevier, Allison Cutuli, Ed Lowe, Gerald Mitchell, Sherene Hymsion, Wanda Lundy, and Felicia Eubanks. (Photograph by Guy Stanley.)

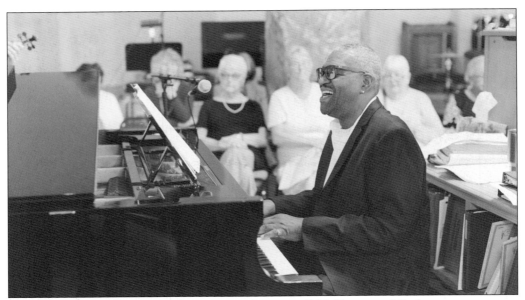

Parish music director Carl Clendenning joined Gesu in 1984. He masterfully fuses contemporary songs, old hymns, spirituals, and instrumentals to showcase the choir's talents. His expertise helped bring the vitality of diversity to Gesu's musical expression. (Photograph by Mae Stier.)

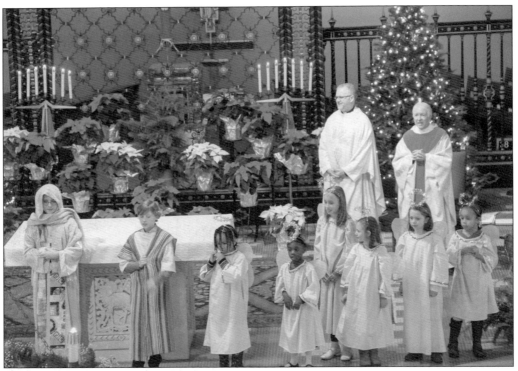

The Christmas Eve Youth Mass at Gesu features an annual Nativity play with parish youngsters dressed as angels and shepherds at the birth of the baby Jesus. Standing behind the children at the December 24, 2016, Mass are Gesu's associate pastor, the Reverend Phillip Cooke, and Gesu's pastor, the Reverend Robert Scullin. (Photograph by Mark Lezotte.)

The ritual of the Catholic Mass brings a faith community together. Gesu parishioners cross the aisles to hold hands during the recitation of the "Our Father" prayer. All ages are welcome at Gesu. (Both, photograph by Diane Weiss.)

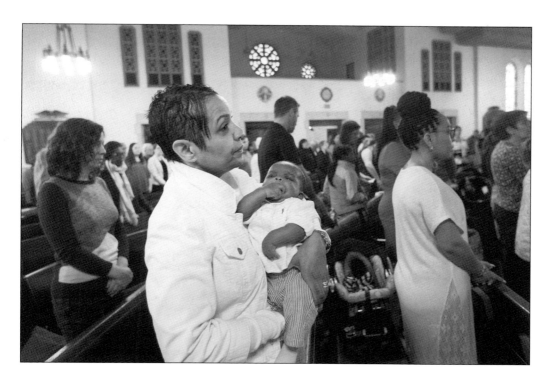

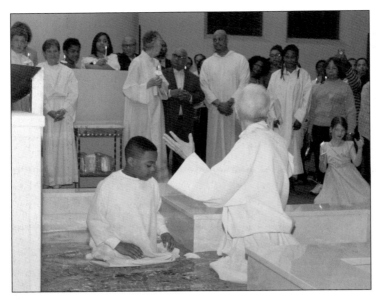

At the Easter Vigil Mass on April 15, 2017, Gesu debuted its new baptismal font and immersion pool. CM Architects, led by Gesu graduate Mary Clare McCormick, recycled marble and railing left over from the 1987 church renovation into the design. In this photograph, Christopher Forbes, 10, awaits the moment Fr. Robert Scullin will dip his head into the baptismal waters. (Photograph by Guy Stanley.)

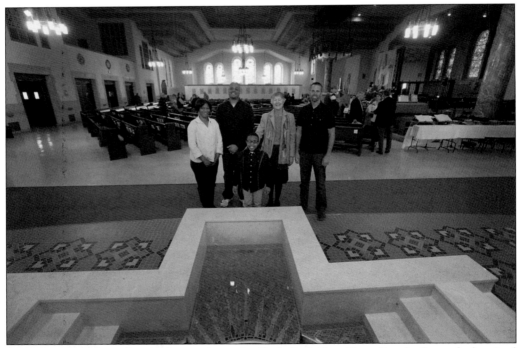

More than 11,000 people were baptized into the Catholic faith at Gesu. But the first to be baptized in the new baptismal pool were Bola (left), Jabari Prempeh (second from left), and Christopher Forbes (standing in front). Sister Angela Hibbard (second from right), Gesu pastoral associate, prepared them for the sacrament. At far right is Kurt Harvey, who was received into the church by making his First Communion and Confirmation at the Easter Vigil Mass. (Photograph by Diane Weiss.)

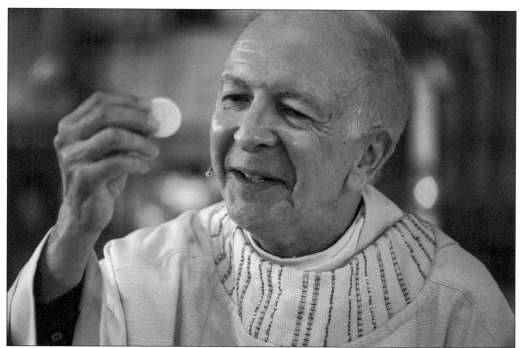

The Reverend Robert Scullin, the Jesuit priest who has been Gesu's pastor since 2009, distributed Communion at Mass on April 23, 2017. Shortly afterwards, Scullin received a new assignment to become the spiritual director for retired Jesuit priests who live at Colombiere Center in Clarkston, beginning in fall 2017. (Photograph by Diane Weiss.)

At worship, a Mass goer's faith is in silhouette against the west stained-glass windows of Gesu on April 23, 2017. (Photograph by Diane Weiss.)

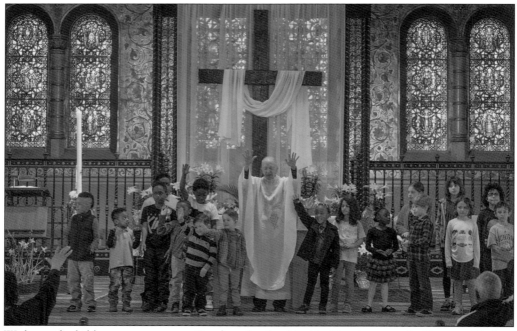

With parish children set to scurry to Sunday school at his side, Gesu's pastor, the Reverend Robert Scullin, raises his arms in blessing. (Photograph by Diane Weiss.)

The church steeple of Gesu and the cross that arises from its center are symbols of stability, sanctuary, and faith in northwest Detroit. (Photograph by Diane Weiss.)

About the Organization

In 2022, Gesu Catholic Parish will celebrate 100 years of faith-building and service in Detroit. Today, Gesu parishioners from more than 500 registered households welcome visitors to celebrate Mass with them.

Gesu School, founded in 1925, enrolled 241 students from pre-K through eighth grade in the 2016–2017 school year. Gesu's school population mirrors Detroit's population, and 89 percent of students are African Americans. Some 25 percent of its students are Catholic. At one time, Gesu students all came from within its parish boundaries, roughly a two-square-mile radius around the school. Now, Gesu educates pupils from over 40 zip codes, including from Detroit suburbs such as Ferndale, Livonia, Bloomfield Hills, and Southfield.

The school's tuition for the 2016–2017 school year was $4,400. The Gesu Angel Fund, established in May 2015, helps defray costs for needy students, with annual grants of up to $1,000. Benefactors and alumni have contributed more than $110,000, including a $75,000 donation from the Marion and Addison Bartush Fund and a parishioner who gives $10 a month out of a fixed income. Paul Schervish and Terese Chipman gave a $50,000 matching grant to Gesu School, in tribute to a friendship with Rev. Robert Scullin that dates back to high school.

Portions of proceeds from this book will go to support Gesu School.

"The number one reason families leave us is because they cannot afford us," said Gesu principal Christa Laurin. "Father Scullin came up with the idea of establishing the Angel Fund to help families fill the gap."

Gesu School also has been awarded $750,000 in grants from the UAW-Ford National Program Center to make building improvements. The school is poised for accelerated growth, as Detroit's revitalization draws young families to the neighborhood. Gesu Parish is a community asset and borders a neighborhood anchored by the University of Detroit Mercy and Marygrove College, an area targeted by the City of Detroit for innovative development.

More than 4,000 Gesu graduates are members of an alumni and friends network and receive a newsletter twice a year. To receive this newsletter, e-mail Gesu community outreach coordinator Anita Sevier at sevier.a@gesudetroit.org or call 313-863-4677.

Learn more about Gesu Parish at www.gesudetroit.com or visit the Facebook page Gesu Catholic Church and School. Weekend Masses are at 5:00 p.m. on Saturday and 8:00 a.m. and 10:30 a.m. on Sunday at Gesu Catholic Church, 17180 Oak Drive, Detroit, Michigan 48221.

DISCOVER THOUSANDS OF LOCAL HISTORY BOOKS
FEATURING MILLIONS OF VINTAGE IMAGES

Arcadia Publishing, the leading local history publisher in the United States, is committed to making history accessible and meaningful through publishing books that celebrate and preserve the heritage of America's people and places.

Find more books like this at
www.arcadiapublishing.com

Search for your hometown history, your old stomping grounds, and even your favorite sports team.